BY STEAMER TO THE KENT COAST

ANDREW GLADWELL

AMBERLEY

First published 2013

Amberley Publishing
The Hill, Stroud
Gloucestershire, GL5 4EP

www.amberley-books.com

British Library Cataloguing in Publication Data.
A catalogue record for this book is available from the British Library.

ISBN 978 1 4456 0375 9

Typeset in 10pt on 12pt Sabon.
Typesetting and Origination by Amberley Publishing.
Printed in the UK.

Contents

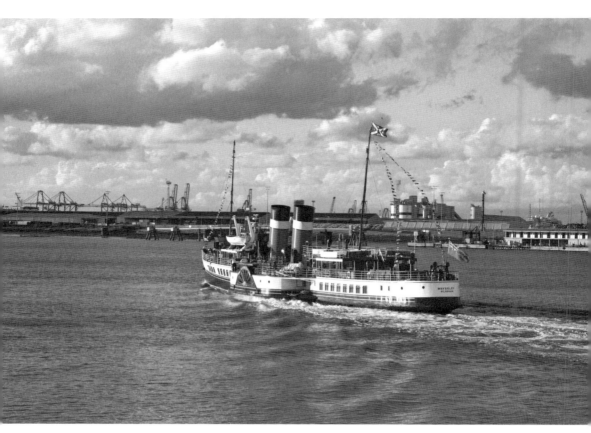

The world famous *Waverley* leaving Gravesend for London in 2012. The towns and resorts of Kent have been popular with Londoners since Victorian times. The best and most popular way of getting to the seaside was by one of the famous pleasure steamers of the Eagle Steamer fleet, such as the *Royal Daffodil, Royal Eagle, Royal Sovereign* or the *Queen of the Channel.*

Acknowledgements

This book has been written to evoke the heritage and atmosphere of the famous and well-loved pleasure steamers that plied their trade to the well-loved seaside resorts of Kent from London, North Kent and Essex. This book intends to evoke the 'Golden Age' of the famous 'Eagle & Queen Line' and to illustrate what made their pleasure steamers so special for generations of day trippers who wanted to visit the numerous seaside resorts of Kent. It's also intended to act as a guide to what they found at their final destination at fun-filled places such as Margate, Herne Bay, Ramsgate and Deal. It's a celebration of the piers, resorts and pleasure steamers of the Kent coast. In compiling this book, I have been grateful for the help and co-operation of several individuals. In particular, I would like to thank Captain Ian Clarke, John Lidstone, John Richardson, Roy Asher, Frank Jones, Jean Spells and David Williams.

Websites

For further information on the heritage of paddle and pleasure steamers;
www.heritagesteamers.co.uk

For details of cruises by the pleasure steamers *Balmoral* and *Waverley*;
www.waverleyexcursions.co.uk

For details of the Paddle Steamer Preservation Society;
www.paddlesteamers.org.uk

For details of the paddle steamer *Medway Queen*;
www.medwayqueen.co.uk

Map showing G.S.N. Steamer and Railway Services

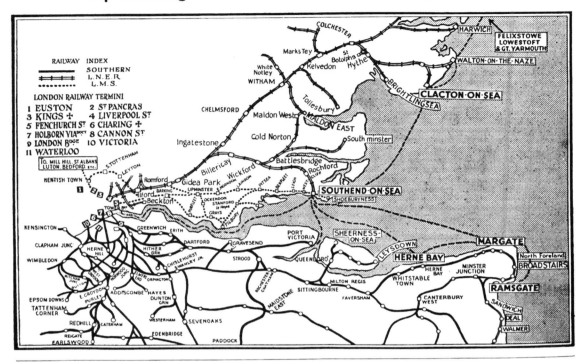

Bradley & Son, Ltd., 115 Fleet Street, London, E.C.4 ; and Reading.

The seaside resorts of Kent provided a wide variety of destinations for passengers using the famous pleasure steamers of the General Steam Navigation and New Medway Steam Packet fleets from London and elsewhere.

Introduction

The well-loved seaside resorts of Kent have been popular destinations and embarkation points for pleasure steamers for almost 200 years. Paddle steamer services started from London in the 1820s. At the time, the seaside resorts were very small and nothing at all like the developed resorts that emerged in the latter years of the Victorian age. This was a time when steam transport was in its infancy and for the first time, people were able to travel easily and quickly to the Kent coast. Early paddle steamers were usually small and lacked passenger facilities. Piers similarly were usually wooden and functional. By the mid to late Victorian age, the design of paddle steamers had evolved to a point where they wouldn't change for many decades. Fondly remembered steamers such as *Royal Sovereign*, *La Marguerite* and *Koh-i-Noor* entered service as bold Victorian statements of paddle steamer supremacy. Piers had also developed spectacularly at the time and had become longer to cater for the larger steamers that were required for the ever-increasing appetite of people that wanted a day at Margate, Ramsgate or Herne Bay from London. They had also become more elaborate with wonderful, opulent pavilions and theatres upon their decks. The marriage of paddle steamer, pier and seaside amusements reigned supreme and provided the perfect antidote for those wanting to escape from the hard everyday life of Victorian and Edwardian London.

Passengers always had a special day out when they travelled by paddle steamer. The steamers gave passengers a high level of comfort and amenities regardless of what class they travelled in. For many, they wanted comfortable saloons in which to enjoy a meal or to simply relax. Others required a more lively time and preferred to spend the trip on the steamer in the busy bar. It was their big day out for the year so they intended to enjoy it and to spend every last penny of their hard-earned wages! All, though, enjoyed a relaxing trip watching the scenery of the River Thames passing by. Paddle steamers also enabled passengers of different classes to travel together on one vessel. Classes were of course segregated, with those spending the most having the best views from more spacious lounges while those spending the least usually had more confined spaces, usually without the views offered to their superiors. They all, though, enjoyed a trouble-free trip to the seaside on what for most was one of the most anticipated days of the year.

The development of steamer services to Kent initially centred around the vast and hugely popular pleasure gardens at places such as Rosherville at Gravesend.

During the early years of the Victorian era, Gravesend was an easily accessible place for the very earliest paddle steamers. The construction of the Town Pier along with the pier at Rosherville enabled people to travel on a day trip from London at a time when transport for the masses was just starting. Within two decades, train services were quickly spreading to link the towns, villages and coastal resorts of Kent. Very soon, paddle steamer services started to spread further afield to call at largely undeveloped resorts such as Margate and Ramsgate. Places such as Rosherville never regained their popularity, especially as the fully developed Victorian seaside resorts of Margate, Ramsgate, Herne Bay and Deal developed to contain facilities that more than amply catered for the masses, unlike the more restrained gardens at Rosherville. Piers were developed to accommodate newer and larger steamers. The Thanet resorts, with their easy links to Essex resorts such as Southend, were ideally placed to capture the massive trade on the Thames.

Margate became the most popular calling point for the Eagle Steamers. Its famous sands were adjacent to the busy jetty. Its most popular attraction was the famous Dreamland amusement park that contained such memorable rides as the Big Dipper, Racing Coaster and the Caterpillar. Numerous pubs as well as mass catering at places like Dreamland ensured that Margate became one great factory of fun. The smaller calling points such as Deal and Herne Bay had excellent piers but the facilities that existed for passengers were more modest. Ramsgate was quite unique as it possessed a large and fine harbour along with excellent sands. But the Kentish coastal resorts offered another exciting option for passengers, as their proximity to France allowed them to act as calling points for pleasure steamer cruises to Boulogne and Calais. The seaside resorts of Kent became lucrative and vitally important calling points for the Eagle Steamers.

The 1920s and 1930s saw the Kent resorts experience their heyday. The mid-1930s saw a great explosion in the popularity of pleasure steamers. Sleek new motor ships entered Thames service and one of the most famous of them all – *Royal Daffodil* – entered service in 1939.

After peace in 1945, the war-ravaged fleet was replenished. The entry into service of the two new motor ships showed significant confidence in the future of services. After the war, services initially flourished but within a decade, services were contracting. A surprising addition was the construction of the bold new pier at Deal that was opened in 1957. Margate, Ramsgate and Deal, like the pleasure steamers that once served them, would never see the good old days return again. By 1963, the famous and heroic *Medway Queen* was laid up. The decline of the fleets during the 1950s and 1960s was swift and inevitable.

The saddest news came from the once invincible General Steam Navigation Company just before Christmas in 1966. The three large and luxurious motor ships were to be withdrawn and the *Royal Daffodil* was the first to go. *Queen of the Channel* and *Royal Sovereign* were sold for service elsewhere. They had quite successful new careers and lasted quite a time after the *Royal Daffodil*. *Queen of the Channel* was finally scrapped in 1984 and the *Royal Sovereign* went in 2007.

The decades that followed saw the piers of the Kent coast significantly deteriorate. Matters were worsened by the harsh winter storms of the late 1970s when both Margate and Herne Bay piers were severely damaged. The arrival of *Waverley*, *Balmoral* and *Kingswear Castle* on the Thames and Medway witnessed

a gradual revival of services. Their visits from the late 1970s onwards brought the tradition of a pleasure steamer cruise to a whole new generation of passengers and long-forgotten landing stages at piers were bought back to life.

Luckily, the great tradition continues. A cruise by pleasure steamer to the Kent coastal resorts has always been regarded as one of the nicest ways to get to the seaside. These steamers, with their happy and evocative names, colourful liveries and luxurious interiors, became a much cherished way of getting to the coast. Steamers such as the *Royal Daffodil*, *Medway Queen*, *Royal Sovereign* and *Queen of the Channel* became part of everyday life and their names are still fondly remembered today. For many, there was simply no better way to visit the seaside! When passengers arrived at Margate, Ramsgate or Herne Bay, the day was always a great ritual where people planned their day out to visit their best-loved attraction such as Margate's Dreamland, had a walk along the promenade and topped their day off with fish and chips and an ice cream! They then ran along the pier for the journey home to London and of course they relished seeing the magical sight of a floodlit Tower Bridge open for them at the very end. The magical mix of sea air, gleaming brass and a sampling of traditional seaside entertainment at Margate, Whitstable or Ramsgate is still as popular as ever. This great London and River Thames pleasure steamer tradition is still alive and still evolving with the splendid pleasure steamers *Waverley* and *Balmoral*.

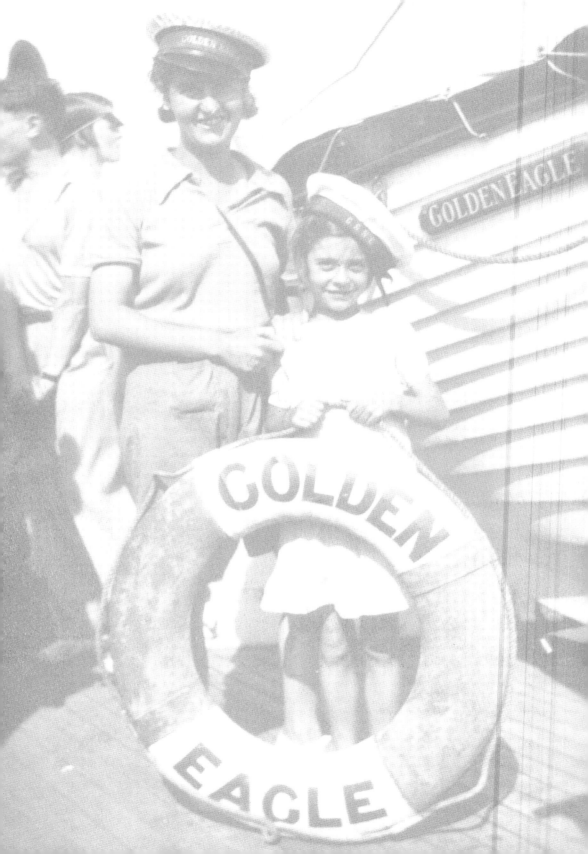

Early Paddle Steamers to Kent Resorts

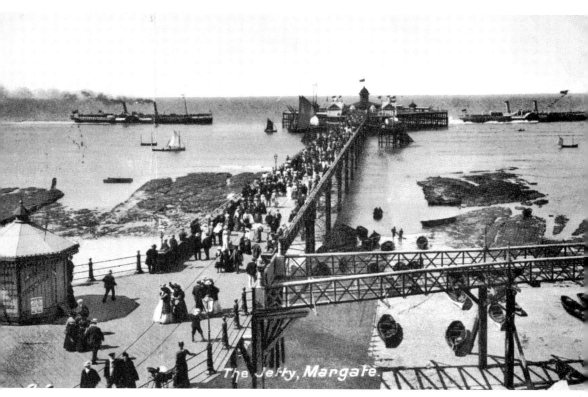

The Jetty, Margate.

Paddle steamer services to Kent expanded during the Victorian era. They competed with the railways and by 1900 there was an extensive map of steamer routes. These continued to expand and contract during the following seventy years.

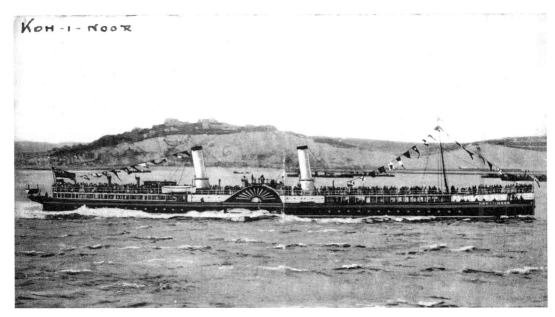

Koh-i-Noor

Koh-i-Noor passing Dover while part of the New Palace Steamer fleet. She was one of the largest paddle steamers to ever cruise on the Thames. The Prince of Wales Pier at Dover was the pier that most pleasure steamers called at from London before the Second World War. The memorial stone of the 3,000-foot-long pier was laid by King Edward VII in 1893.

Cynthia in the harbour and *Koh-i-Noor* arriving at Ramsgate around 1893. Ramsgate gained its popularity due to the summer patronage of royalty such as George IV. He once spent an entire season at Ramsgate rather than Brighton.

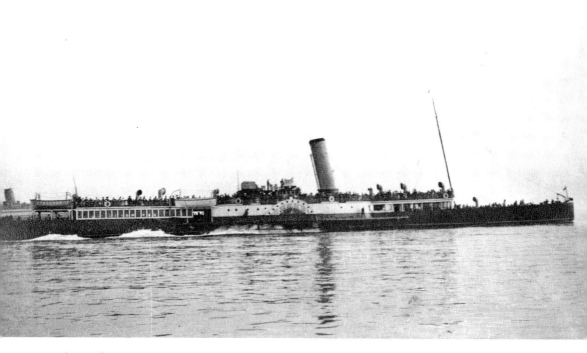

London Belle at sea in August 1927. The period from 1888 witnessed considerable growth in the holiday and excursion trade. The formation of the Belle Steamer fleet was perfectly positioned to take advantage of this increase in trade. *Clacton Belle* soon entered service and was quickly joined by the *Woolwich Belle* and *London Belle*. This was a period of significant competition and the Victoria Steamboat Association was building ever larger and more luxurious vessels. The Clacton company was forced to introduce new tonnage to maintain its position and *Southend Belle* was swiftly ordered. The Clacton company also had to reconstitute itself as Belle Steamers. Piers such as those at Walton, Southwold and Clacton were influenced and owned by Belle Steamers. *Southwold Belle* entered service in the summer of 1900. Just five years later, the company was facing financial troubles and was wound up with its assets taken over by the Coast Development Corporation. Operations were then extended to provide services to the Kent coast from Essex and cruises along the southern bank of the Thames Estuary. This area was well served by the General Steam Navigation Company and New Palace Steamers, so would never provide the financial benefit the company sorely required.

By the end of the 1911 season, the newest steamer, *Southwold Belle*, was sold to pay off debts. In May 1915, with the First World War at its height and with excursion traffic all but gone, the company went into voluntary liquidation. The assets of the company remained with liquidators until much of the fleet was purchased by Mr Kingsman of Clacton in 1921. The Belle Steamers were some of the finest paddle steamers ever built but their popularity was short lived on the Thames in a period of fierce competition.

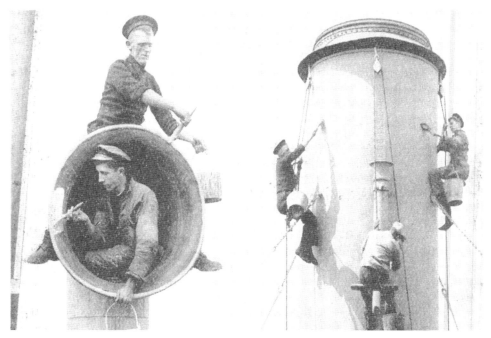

During the 1920s, health and safety was less important than it is now. Here are two images showing the precarious ways of painting ventilators and the funnel of the *London Belle*.

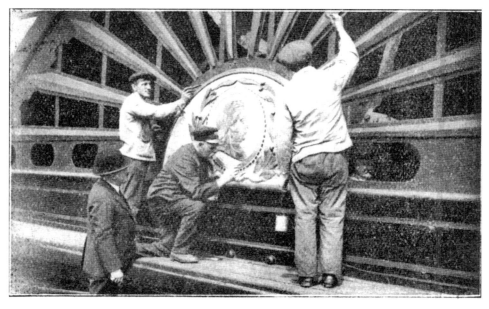

The paddle steamer *Royal Sovereign* was one of the largest steamers ever to ply the Thames. Here, her crew touch-up the paintwork on her massive paddle box. Happily, the fine carving shown here of Queen Victoria was saved by the Paddle Steamer Preservation Society during the 1960s.

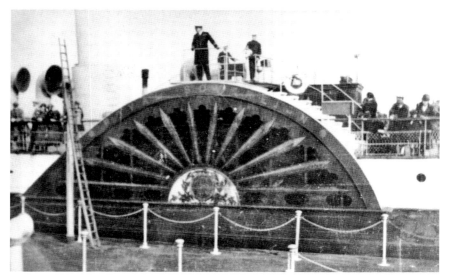

The massive paddle box of the *Royal Sovereign*. Her size meant that she was able to provide a wide range of facilities for her passengers. This included a book stall, barbershop, confectionery stall and bathrooms. At the end of her career she was sold by the GSNC for the sum of £5,540.

Royal Sovereign at Ramsgate. This steamer was well known for operating services to the main Kent seaside resorts of Margate and Ramsgate from London. She was widely advertised as 'London's Favourite Steamer'. She had excellent facilities for her passengers and these can be appreciated in this view.

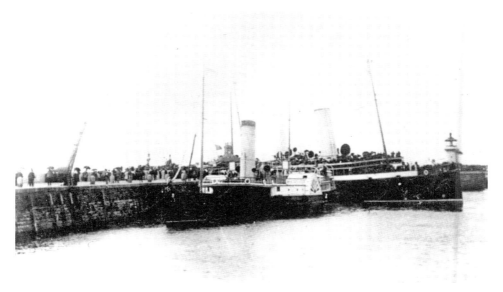

Oriole and *La Marguerite* at Ramsgate around 1895. Ramsgate harbour dates from 1795 and the two breakwaters enclose an area of 42 acres. The construction of the harbour cost around £1,500,000. The east pier was enlarged in 1894 to accommodate the large paddle steamers that called at the resort.

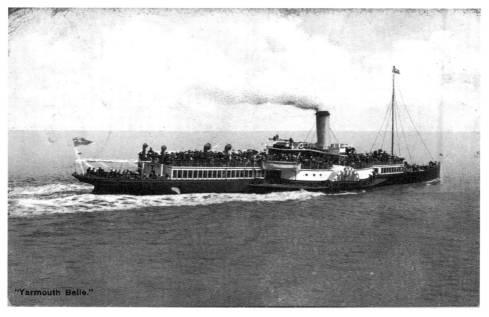

"Yarmouth Belle."

Yarmouth Belle had a long life for a paddle steamer and was regarded as being quite economical. Her career though was marked by the number of changes in ownership and names due to the decline of the Belle Steamer fleet. *Yarmouth Belle* was one of the Thames paddle steamers that took part in the 1902 Coronation Fleet Review of Edward VII.

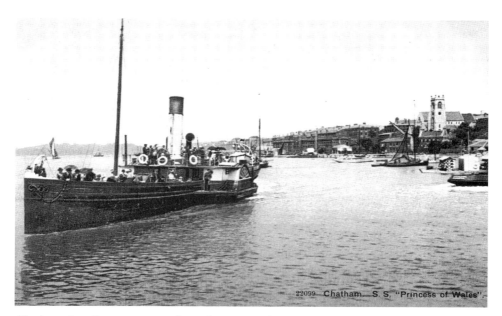

Chatham Sun Pier was a popular calling point for the Kent-based Medway Steam Packet fleet. The *Princess of Wales* is shown here approaching the pier around 1910. To the right are the buildings of the Royal Naval Dockyard. The dockyard was always a hive of activity and passengers aboard the steamers were allowed a brief look into the secret world of its workings from the deck of the steamers.

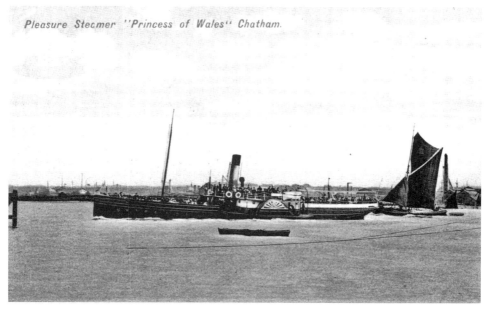

Princess of Wales approaching Sun Pier at Chatham. The *Princess of Wales* was the first Medway steamer to go to Herne Bay in around 1904.

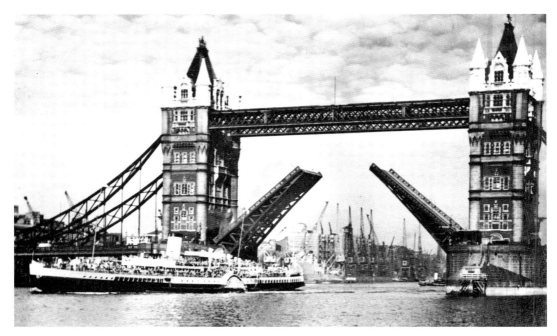

Royal Eagle was built in 1932 for the GSNC and had a speed of 18.5 knots. Her regular season was from Whitsun to the middle of September each year. She normally cruised every day of the week apart from Friday. Her well-known service was between London, Southend, Margate and Ramsgate.

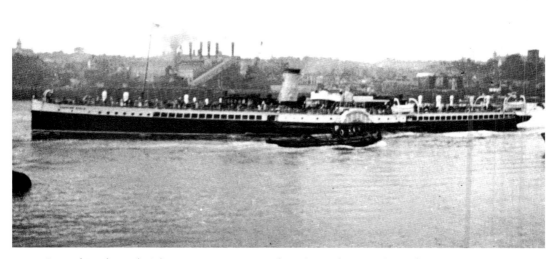

Crested Eagle on the Thames in 1928. *Crested Eagle* was later used as a floating grandstand for the Coronation of George VI in 1937 on the Thames Embankment in London.

Golden Eagle had a long association with Kent seaside resorts. She entered Thames service in 1909 and was regarded as the finest-looking of all River Thames paddle steamers. She had a relatively long career and was withdrawn after the Second World War before being scrapped.

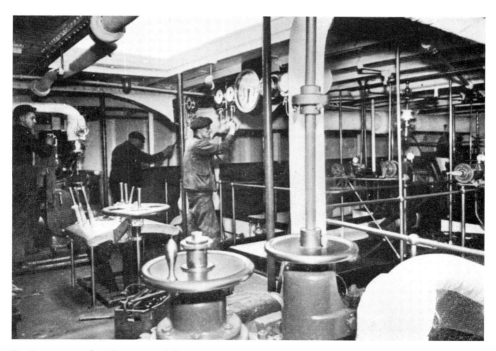

Engine room of a Thames paddle steamer. Engines were always a popular attraction on the pleasure steamers to the Kent coast. Each paddle wheel of the *Royal Eagle* had eight floats. Each of the *Royal Eagle*'s paddle wheels weighed 25 tons.

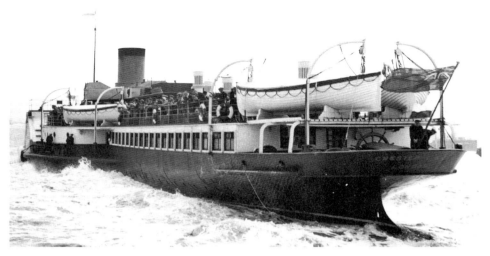

The distinctive-looking *Crested Eagle* was well known for the speed at which she could depart a pier. She had been built at the J. Samuel White yard at Cowes and became the first post First World War paddle steamer to enter service on the Thames. She was built with a folding mast and funnel for service from Old Swan Pier. A few years later Tower Pier was built, thereby ending these calls.

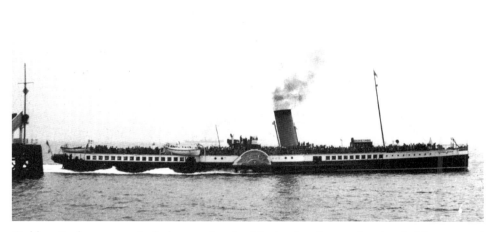

Golden Eagle was particularly associated with the London to Southend, Margate and Ramsgate route. She was named 'The Happy Ship' in publicity material and was aimed at the family market segment. There were lots to do aboard for children, including balloon-blowing contests, jumping, skipping and other party activities.

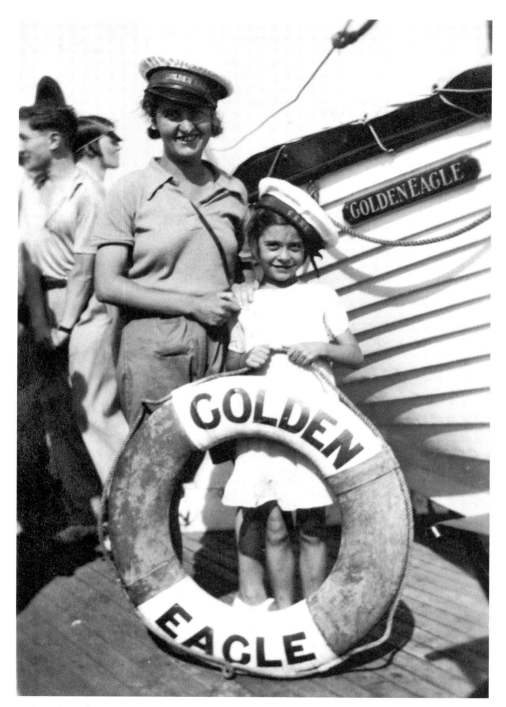

A day aboard an Eagle Steamer was incredibly popular during the inter-war years. Most families though didn't have cameras. Photographers often greeted passengers as they disembarked from the steamers and captured them as they strolled along the prom at Margate or Ramsgate.

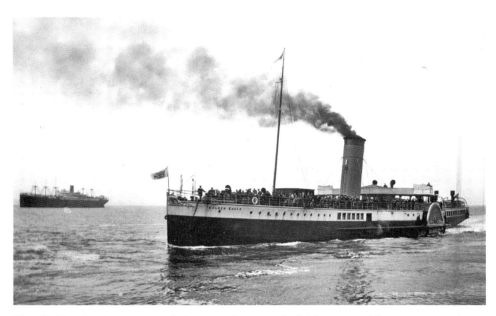

The *Golden Eagle* was one of the most famous of all Thames paddle steamers and was perhaps the most graceful-looking member of the fleet. Her regular run was to the Kent resorts of Margate and Ramsgate and occasionally to Boulogne.

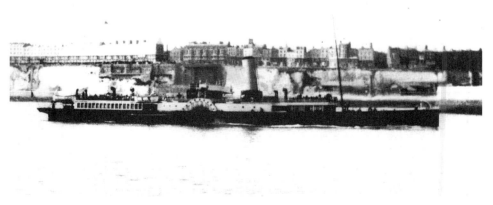

Essex Queen departing from Ramsgate. Originally built as *Walton Belle* in 1897 for the Belle Steamers, she was eventually sold in December 1925 to the NMSPC and renamed *Essex Queen*. She mostly operated cruises from Chatham and Sheerness to Southend and Margate and was one of the steamers that helped the company to significantly expand its services.

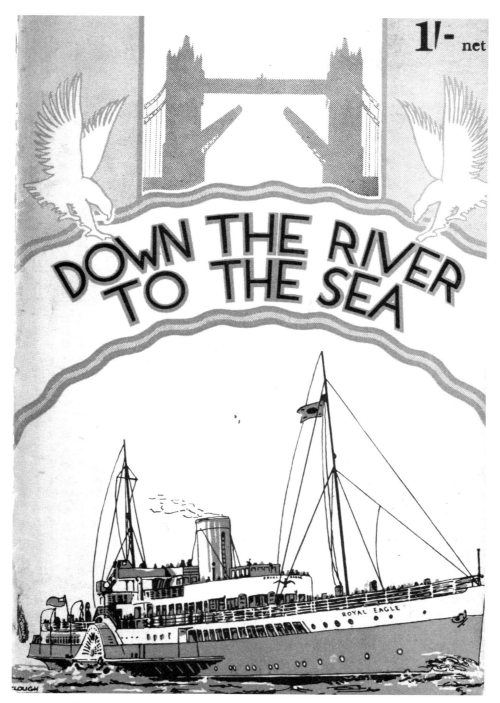

1/- net

DOWN THE RIVER TO THE SEA

ROYAL EAGLE

Steamer guide from 1934. In 1896 there were more than a dozen pleasure steamers running from London, with only one from Chatham. By 1914, the number of London boats had dropped to nine and from the Medway had risen to three. By 1930, Rochester had twice as many pleasure steamers operating as London.

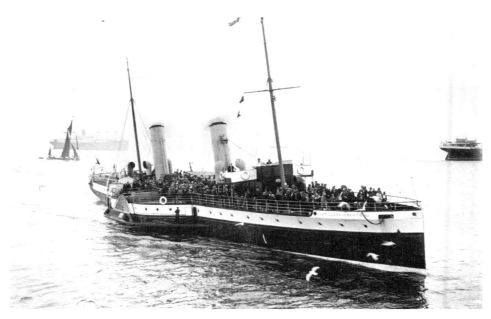

Queen of Kent in her Thames heyday. Rochester was the home of the Queen Line. The company offices were at 365 High Street. The Acorn Ship Yard at Rochester provided the shipyard facilities required by the steamers. The company house-flag incorporated the rampant white horse of Kent as its main feature to reinforce its strong link with Kent and its resorts.

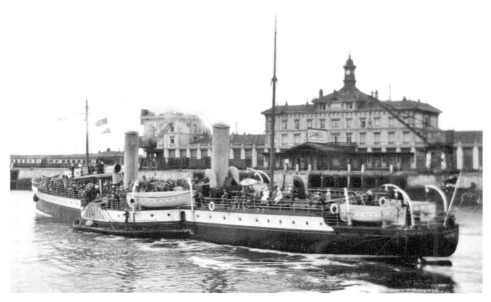

The New Medway Steam Packet Company was formed with the enigmatic Captain Shippick as managing director. It soon went about transforming the fleet by adding new steamers capable of holding up to 1,700 passengers. A popular enterprise was the continental services from Chatham, Sheerness, Southend and Margate to Calais three times a week during the summer. *Queen of Kent* was one of the steamers that operated this service.

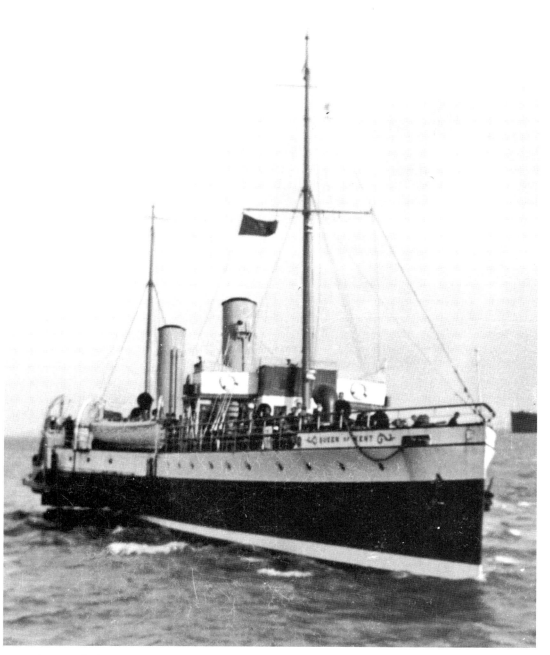

Queen of Thanet in 1936. Both the *Queen of Kent* and *Queen of Thanet* had interesting careers. They were initially built as minesweepers during the First World War. After service on the Medway and Thames, they soldiered on for a time before being scrapped.

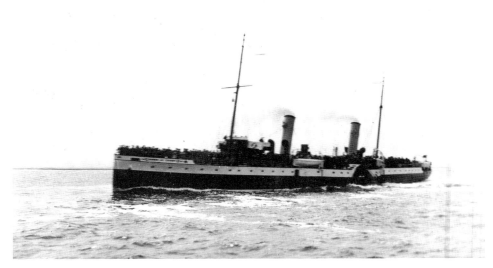

The *Queen of Kent* and *Queen of Thanet* were very distinctive with their two tall, widely spaced funnels. This was made necessary by the fact that they had boiler rooms both forward and aft of the engine room. They were both converted to oil-burning in 1931 as well as having new paddle wheels fitted to give greater speed.

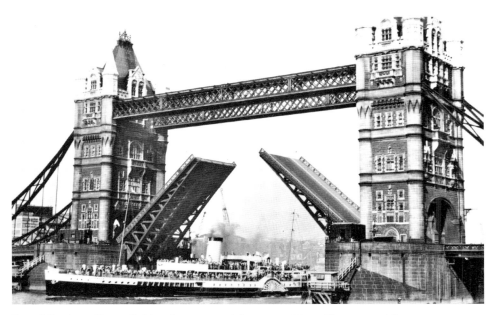

Royal Eagle at Tower Bridge. It was usual for many River Thames paddle steamers to go astern for the final part of the journey towards Tower Bridge so that they were in the correct position for the following day. *Crested Eagle* had a bow rudder fitted especially to do this. Tower Bridge could be opened in less than two minutes. This left a free height of 150 feet and a passageway that was 200 feet wide.

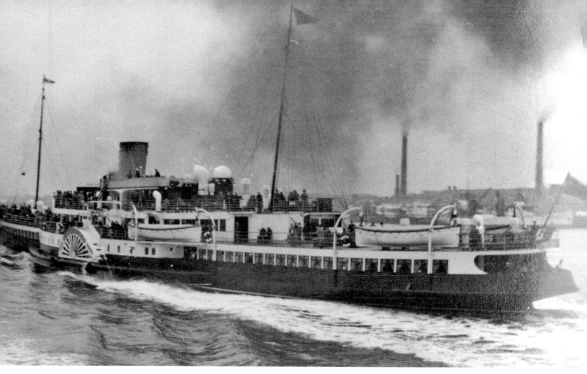

Royal Eagle cruising off Rosherville in 1936. Rosherville Gardens was laid out in 1837 and located in a disused chalk pit at Northfleet next to Gravesend. The gardens covered an area of some 17 acres and had a full title of the 'Kent Zoological and Botanical Gardens Institution'. At one time, the gardens were managed by Baron Nathan, who had an act that saw him dance blindfolded across a stage that was covered with eggs. Rosherville Gardens included such features as dancing bears, a baronial hall, Greek temples and ruins, a theatre and a lake. A poplar feature for visitors was the night-time illumination of the gardens with hundreds of coloured glass lights. The famous trapeze artist Blondin appeared at the gardens as well as the Sousa band. The gardens witnessed their greatest popularity during the 1850s. In 1857, 20,000 people visited the park each week with many of these arriving by paddle steamer. By 1880, the gardens had reached the peak of their popularity. With ever-increasing competition from the railways they closed in 1901. They had existed for the entire reign of Queen Victoria. They did though experience a brief revival two years later when they were involved in early film-making. The site was later developed as the Henley Telegraph Works. During the Second World War, the PLUTO cable was produced on the site as well as other projects that helped the war effort.

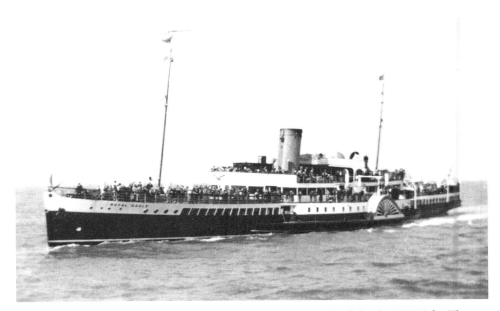

Royal Eagle in 1933. *Royal Eagle* was the last paddle steamer built by the GSNC for Thames service and entered service in May 1932. She was launched by Lady Ritchie at Birkenhead with a bottle of whisky. This was the first time that this had been recorded. *Royal Eagle* could carry 2,000 passengers on four decks of luxury passenger accommodation.

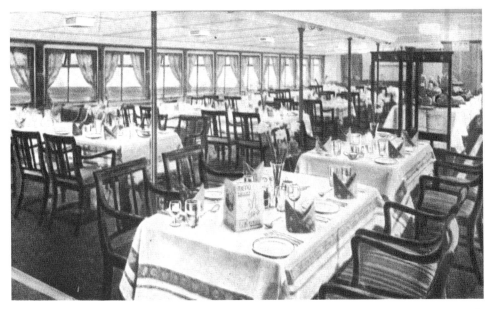

Dining was always a great tradition aboard Thames pleasure steamers to the Kent seaside resorts. Many preferred to experience a meal in one of the grand dining saloons such as this one on the *Royal Eagle*. Décor and cuisine was as good as in the London hotels and up to 322 diners could be fed at once in this room. Several sittings were held at each mealtime and up to sixty catering staff looked after patrons.

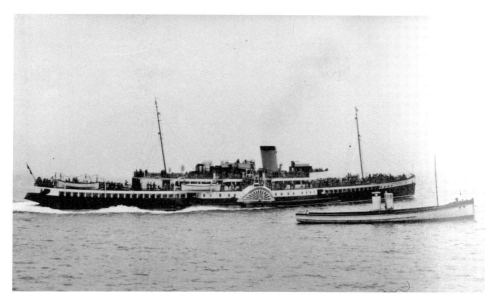

Royal Eagle accompanied the Cunard liner *Queen Mary* for her departure on her maiden cruise from Southampton in May 1936. She also attended the massive fleet reviews at Spithead in 1935 and 1937. *Royal Eagle* carried around 3,000,000 passengers between 1932 and 1938.

Part of the deck lounge aboard the *Royal Eagle*. *Royal Eagle* became an anti-aircraft ship during the Second World War. She performed this role particularly well and it was reported in 1943 that she had shot down two German aircraft and had seen fifty-two skirmishes with the enemy. *Royal Eagle* later became the headquarters ship at the time of the construction of the Mulberry harbour.

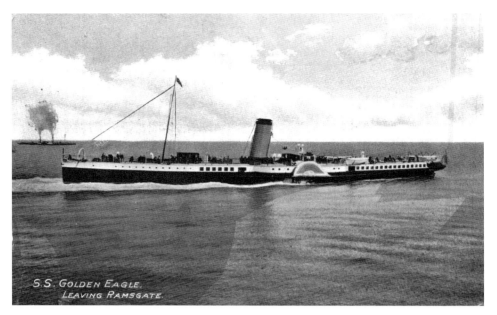

Golden Eagle departing from Ramsgate. She was built by the John Brown yard. She served as a troop-carrier during the First World War and carried some 518,101 troops across the English Channel. During the Second World War she initially helped with the evacuation of children from Gravesend to the relative safety of the East Coast.

Queen of Kent was purchased by the New Medway Steam Packet Company in 1928. She usually provided cruises to the coastal resorts of France such as Boulogne and Calais as well as operating on the Thames and Medway and up to Great Yarmouth.

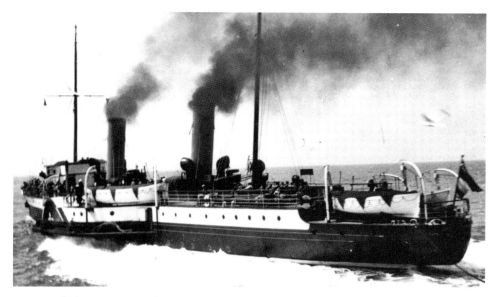

Queen of Thanet's master for a while was the well-known Thames and Medway figure of Captain Tommy Aldis. He was assisted for a while by Leonard Horsham, who later became master of the famous *Medway Queen*. Passengers enjoyed seeing familiar officers and crew on their pleasure steamers. The NMSPC tended to retain staff for many years.

Advertisement for cruises to the Kent coast during the 1947 season by the *Royal Eagle* and other steamers. The first few years after the end of the Second World War were quite exciting for Thames passengers as exciting new pleasure steamers were introduced to run alongside old favourites such as the *Royal Eagle* and *Golden Eagle*.

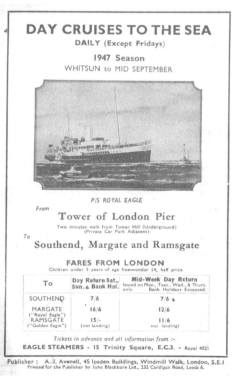

DAY CRUISES TO THE SEA

DAILY (Except Fridays)

1947 Season

WHITSUN to MID SEPTEMBER

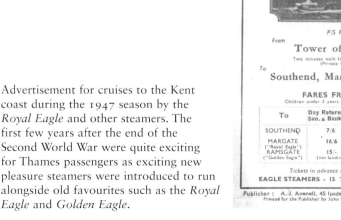

P/S ROYAL EAGLE

From

Tower of London Pier

Two minutes walk from Tower Hill (Underground)
(Private Car Park Adjacent)

To

Southend, Margate and Ramsgate

FARES FROM LONDON

Children under 3 years of age free—under 14, half price

To	Day Return Sat., Sun. & Bank Hol.	Mid-Week Day Return Issued on Mon., Tues., Wed., & Thurs. only. Bank Holidays Excepted.
SOUTHEND	7/6	7/6
MARGATE ("Royal Eagle")	16/6	12/6
RAMSGATE ("Golden Eagle")	15/- (not landing)	11/6 not landing

Tickets in advance and all information from :-

EAGLE STEAMERS - 15 Trinity Square, E.C.3. - Royal 4021

Publisher : A. J. Avenell, 45 Ipsden Buildings, Windmill Walk, London, S.E.1
Printed for the Publisher by John Blackburn Ltd., 232 Cardigan Road, Leeds 6.

Royal Eagle departing from Ramsgate for London during the 1930s. The *Royal Eagle* was the zenith of UK excursion paddle steamers. She was almost twice the size of other large excursion steamers built in the same era like the *Jeanie Deans*. She knocked them all into cocked hats with her unsurpassed and luxurious covered accommodation, bars and saloons. Although initially billed as 'London's New Pleasure Steamer', it wasn't long before she acquired the title 'London's Luxury Liner'.

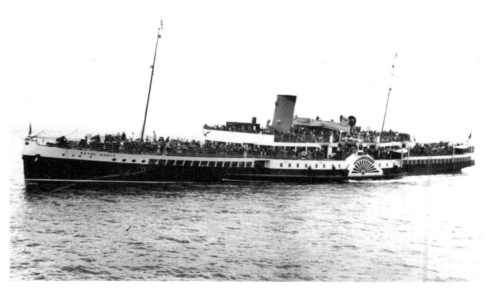

Royal Eagle would take three hours to reach Southend from London and five hours from London to Margate. It took a further forty-five minutes to reach Ramsgate. The return fare from London to Southend was 4s on the *Royal Eagle* and 8s to Margate. These fares could be almost double those on older paddle steamers such as the *Golden Eagle*.

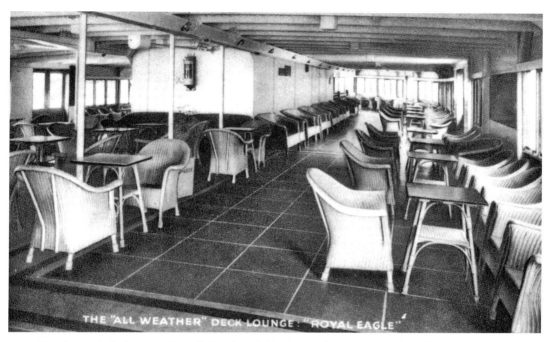

The huge deck lounge aboard the *Royal Eagle* can be appreciated in this 1930s view. Passengers at the time required different facilities to their grandparents and an excellent view was also important.

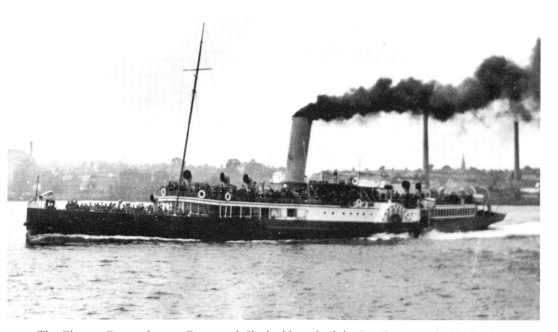

The *Clacton Queen* close to Gravesend. She had been built by Day Summers & Co. in 1897 initially for South Coast service.

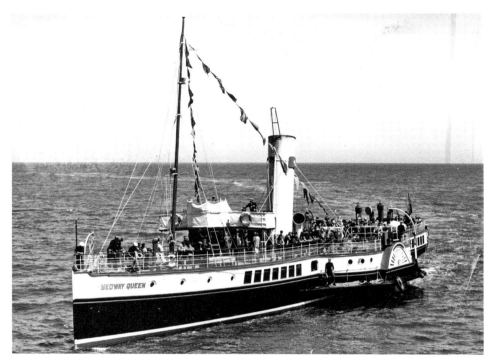

By 1962, the future for the *Medway Queen* was looking far from secure. Despite *Medway Queen* having made seven trips to the beaches at Dunkirk to rescue over 7,000 servicemen, less than two decades later her heroism had faded a little. With old machinery and less than ample upkeep, there was only one option and that was withdrawal from service.

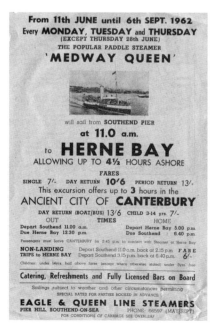

From 11th JUNE until 6th SEPT. 1962
Every **MONDAY, TUESDAY** and **THURSDAY**
(EXCEPT THURSDAY 28th JUNE)
THE POPULAR PADDLE STEAMER
'MEDWAY QUEEN'

will sail from SOUTHEND PIER

at **11.0** a.m.

to **HERNE BAY**
ALLOWING UP TO 4½ HOURS ASHORE
FARES
SINGLE 7/- DAY RETURN **10'6** PERIOD RETURN 13/-
This excursion offers up to **3** hours in the
ANCIENT CITY OF **CANTERBURY**
DAY RETURN (BOAT/BUS) 13/6 CHILD 3-14 yrs. 7/-
OUT TIMES HOME
Depart Southend 11.00 a.m. Depart Herne Bay 5.00 p.m.
Due Herne Bay 12.30 p.m. Due Southend 6.40 p.m.

Passengers must leave CANTERBURY by 3.40 p.m. to connect with Steamer at Herne Bay

NON-LANDING Depart Southend 11.0 a.m. back at 2.15 p.m. **F A R E**
TRIPS to HERNE BAY Depart Southend 3.15 p.m. back at 6.40 p.m. **6/-**
Children under 14yrs. half above fares (except where otherwise stated) under 3yrs free

Catering, Refreshments and Fully Licensed Bars on Board

Sailings subject to weather and other circumstances permitting
SPECIAL RATES FOR PARTIES BOOKED IN ADVANCE

EAGLE & QUEEN LINE STEAMERS
PIER HILL SOUTHEND-ON-SEA PHONE: 66597 (MAY/SEPT)
FOR CONDITIONS OF CARRIAGE SEE OVERLEAF

Southend was a crucial calling point for paddle steamers such as the *Medway Queen* on trips to and from the Kent resorts. A range of bus trips to places such as Canterbury were often inserted into the timetable to offer patrons a wide range of cruises.

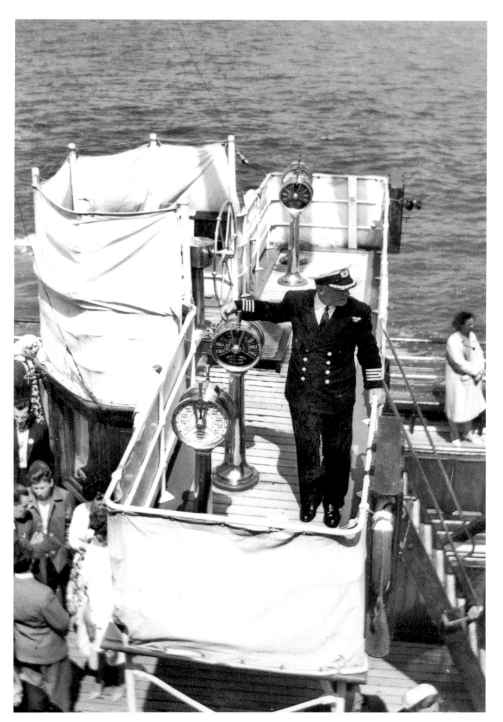

Medway Queen retained an open bridge right until she was withdrawn from service in 1963. Leonard Horsham became her well-loved master and he commanded her on her very last cruise.

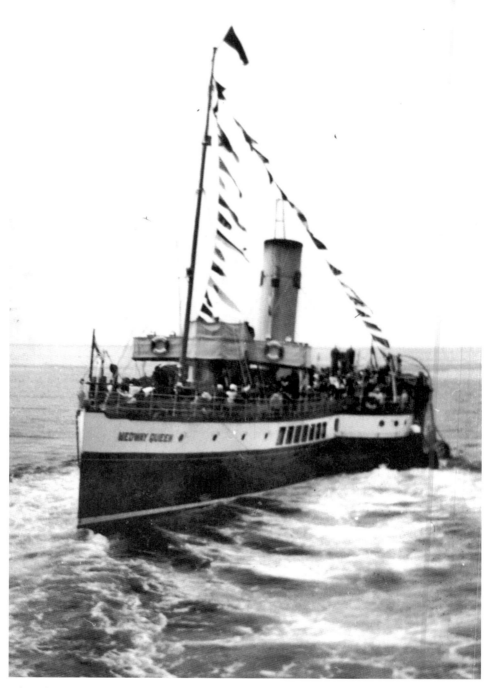

After the 1937 GSNC and NMSPC amalgamation, the Medway company retained some independence but operated as a subsidiary of the GSNC. Right up until the end of the *Medway Queen* in 1963, the steamer showed its old Medway owner's flag and branding.

Departure & Arrival at London

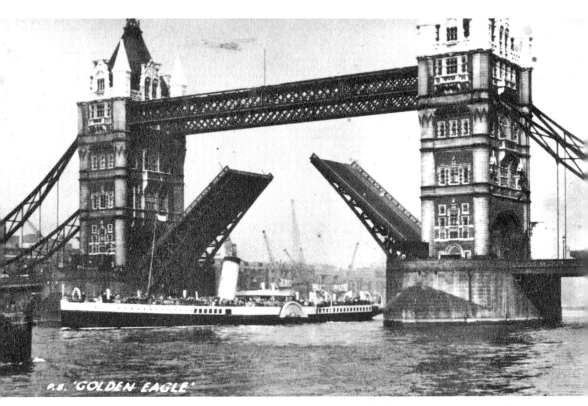

Golden Eagle departing for the day from London. London provided an impressive start and finish for pleasure steamers plying to and from the Kent coast.

Cover for *Royal Thames*, the General Steam Navigation souvenir brochure. It was printed in 1937 and marked the Coronation of George VI. The artwork for the cover accentuates the eminence of the company at the time. It also shows the *Royal Eagle*.

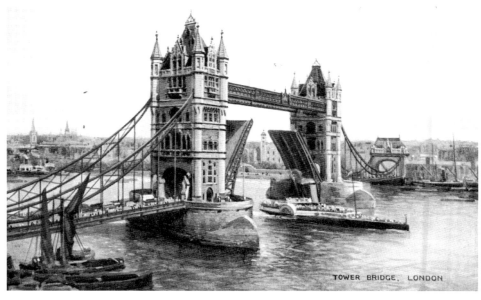

The Belle Steamer fleet was a remarkably successful and distinctive fleet of paddle steamers that operated on the Thames during the Edwardian period. A fine fleet of steamers were built that were named after the main calling points of the fleet. Tower Bridge has always been an integral part of each London cruise. At the time of the Belle Steamers, the bascules were moved by steam power. The bascules are now lifted around 1,000 times a year and ships still take priority over road traffic. Bridge lifts need to be booked and are free to ships of the correct size. A computer system was installed in 2000 to control the raising and lowering of the bascules remotely. It sometimes proved unreliable and this resulted in the bridge being stuck in the open or closed positions on several occasions. Around 40,000 people cross Tower Bridge each day. The total cost of construction in 1894 was £1,184,000. This is equivalent to £100 million today.

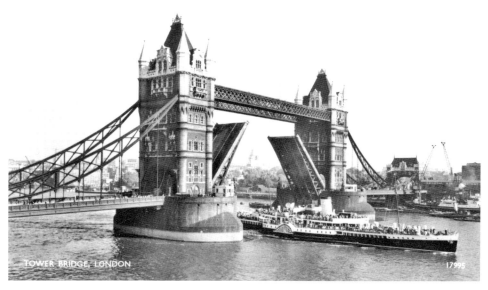

Tower Bridge was opened in 1894 and has provided the perfect start or end to the day for pleasure steamer passengers since that date. In 2012, Tower Bridge was equipped with state-of-the-art LED lights to make the bridge more energy-efficient as well as allowing spectacular light displays to be mounted for events like the London Olympics and the Diamond Jubilee.

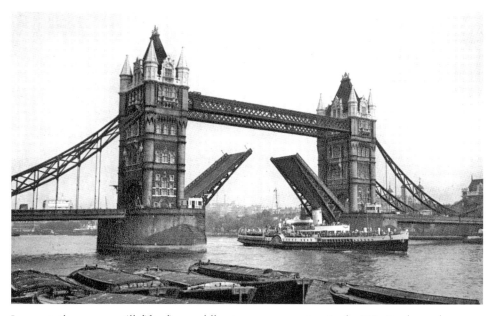

In 1946, there were still fifty five paddle steamers operating in the UK. By the early 1950s the large 'Eagle' paddlers disappeared from the Thames. *Royal Eagle* was the newest paddle steamer in the fleet and despite wartime usage was almost new. Her passenger facilities were indeed impressive and were just as good as those aboard the new *Royal Sovereign* and *Queen of the Channel*.

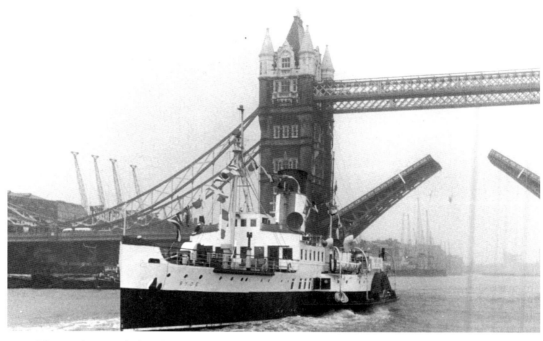

The *Ryde* visited the Thames in 1968 as the 'Floating Gin Palace'. She is seen here on 14 September on her way to the coast. The *Ryde*, like many other pleasure steamers during the 1960s, operated a short programme of cruises at the end of the pleasure steamer era. These attempts at providing a limited and economic service met with little success. It would take another decade before the *Waverley* would provide a successful season of cruises each year.

The sun deck on 'A' deck aboard the *Royal Daffodil*. This steamer had wide-open decks that gave passengers a perfect view of passing Thames scenery.

Part of the bridge of the *Royal Daffodil*.

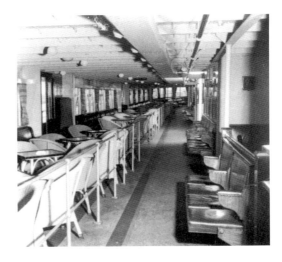

The sun lounge aboard the *Royal Daffodil* on 'B' deck. These lounges were perhaps the largest available on any UK pleasure steamer.

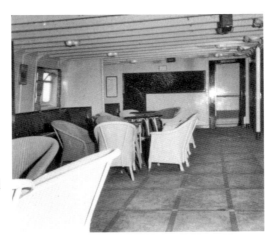

The entrance lounge on 'C' deck aboard the *Royal Daffodil*. The *Royal Daffodil* had the largest passenger capacity of the three Eagle Steamer motor ships.

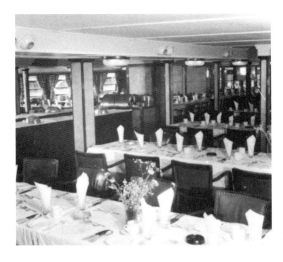

The dining saloon on 'C' deck aboard the *Royal Daffodil*. Dining was quite formal when compared to modern-day standards.

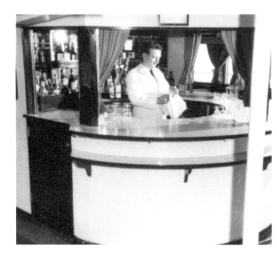

The cocktail bar of the *Royal Daffodil* on 'B' deck. This steamer had extensive food and beverage facilities for passengers.

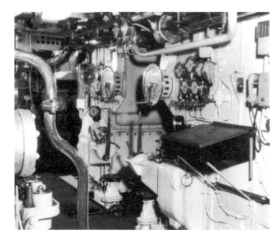

Part of the engine room (lower level) aboard the *Royal Daffodil*.

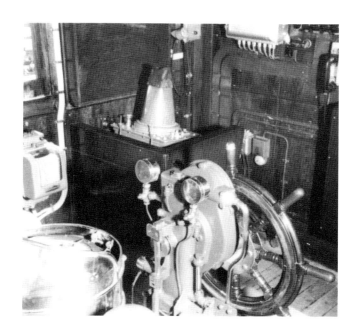

The wheelhouse of the *Royal Daffodil*.

Advertisement for Eagle & Queen Line services to Kent coast in 1937. At this time, the Medway fleet in particular was experiencing its heyday, with a vast array of destinations around the Thames coastline as well as to France and Belgium. Within two years, the Second World War had disrupted services and post-war services never regained

London's Great Pleasure Fleet

EAGLE and QUEEN LINE STEAMERS

Day cruising season from Whit–Saturday to mid-September (Fridays excepted)

Services to and from :

TOWER OF LONDON PIER, SOUTHEND, HERNE BAY, MARGATE, RAMSGATE, ROCHESTER, CHATHAM, SHEERNESS, CLACTON, WALTON, FELIXSTOWE, GORLESTON, LOWESTOFT & YARMOUTH

Also day cruises to the Continental Ports, OSTEND, CALAIS, BOULOGNE, DUNKIRK, etc., with connecting trains from London.

Telephone, wire, write or call for particulars from—

THE GENERAL STEAM NAVIGATION Co. LTD.,
15, TRINITY SQUARE, LONDON, E.C.3. Telephone : Royal 3200

for London Services, or

THE NEW MEDWAY STEAM PACKET Co. LTD.,
365-367, HIGH STREET, ROCHESTER. Telephones : Chatham 2204-5.

Page Sixty-seven

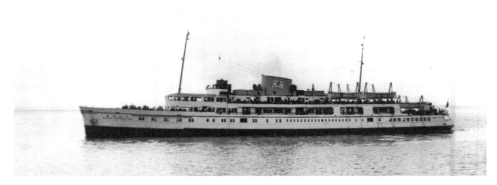

Of the two post-war motor ships, the *Queen of the Channel* had the NMSPC house-flag on the funnel whereas the *Royal Sovereign* had the GSNC house-flag.

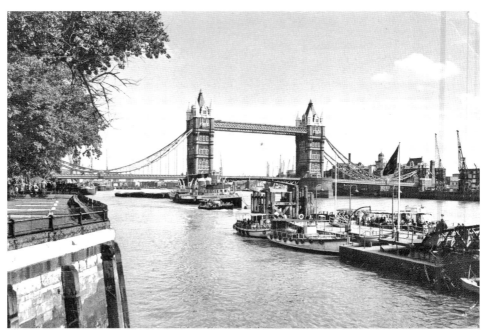

Queen of the South moored close to Tower Bridge during the mid-1960s. *Queen of the South* spent a short but eventful career on the River Thames. She originally operated as the *Jeanie Deans* on the Firth of Clyde before being re-conditioned for Thames service in the mid-1960s.

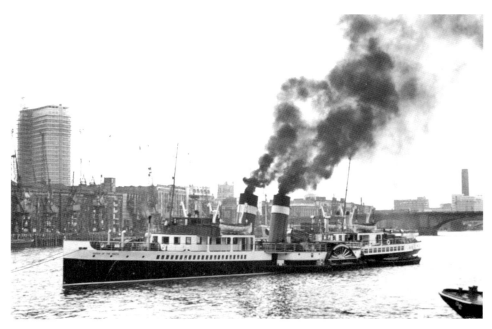

Queen of the South tied up on buoys in the Pool of London in June 1967. In the distance you can see the old London Bridge.

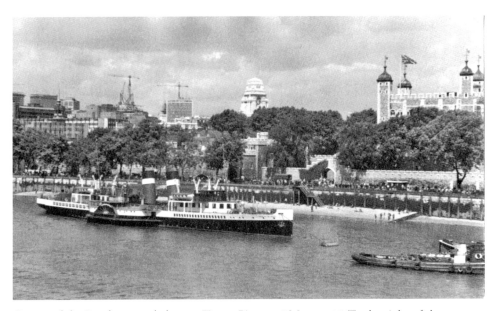

Queen of the South moored close to Tower Pier on 6 May 1966. To the right of the steamer you can see the sandy beach that was created several decades earlier for Londoners. Cockneys would make their sandcastles while watching more prosperous folk going for a day at Margate by pleasure steamer. The old skyline of the City of London is very different to that of the twenty-first century. Cranes can be seen building the first of the skyscrapers.

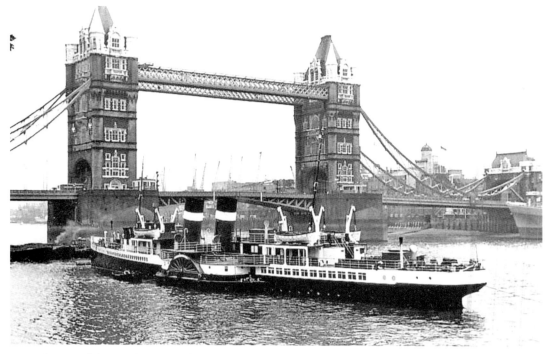

Queen of the South was resplendent in her LNER livery. Mechanical failure, ever-increasing debts and many unhappy passengers meant that she was finally sent for scrapping at Antwerp in December 1967. The *Queen of the South* episode was important in that it gave a great deal of knowledge to would-be operators. This expertise was later used by the operators of *Waverley* from 1978 onwards.

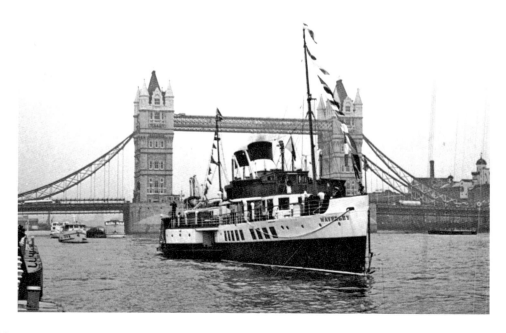

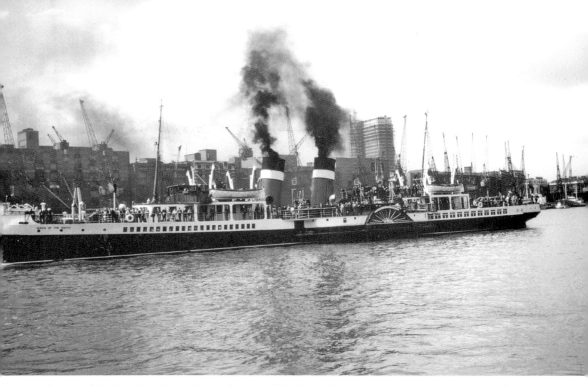

Queen of the South emitting large plumes of black smoke on Press Day – 8 June 1967. The Thames skyline in this area has changed greatly since this photograph was taken. The high-rise Guys Hospital is still being constructed and rows of Thames-side cranes line the bank. The Shard now occupies the area where the black smoke is. This 1,016-foot-high building is the highest building in Western Europe.

The *Queen of the South*'s future initially looked good. Don Rose, who was the South East London businessman behind the venture, hired a captain who had been master of a paddle steamer before. Captain Stanley Woods had been mate of the *Consul* on the Sussex coast in 1963 as well as master of the *Princess Elizabeth*. Captain Woods initially took the *Jeanie Deans* south from the Firth of Clyde to the Thames for her new role as the *Queen of the South*. Sadly, the initial excitement and heavy investment to make the steamer fit for a modern market was never repaid with monetary profit and faultless service.

Opposite below: Waverley visits the Thames and London in 1979. *Waverley*'s arrival on the London River enabled the old calling points of the Eagle Steamers to be resurrected. Luckily, places such as Southend, Tilbury, Clacton and Deal still had adequate landing facilities at that time. During those first few years, *Waverley* would have a quite modest timetable on the Thames. In 1979 for example, she operated on twelve days. A highlight of the early schedule was the Deal to Greenwich and London cruise as well as cruises to view the Goodwin Sands and cruises from Rochester to view the Southend Air Show. Cruises were also offered between Southampton and Deal. Since that time, the timetable has changed to reflect the availability of Thames piers. Some novel cruises have included one to cruise off of the old pier head at Herne Bay, calls at the Millennium Dome Pier, cruises to the French coast and calls at Mistley and Wivenhoe in Essex.

Evening Cruises!

Showboat-style

ABOARD PADDLE-STEAMER
QUEEN OF THE SOUTH
STARTING SATURDAY JUNE 24th.
THURSDAY, SATURDAY AND SUNDAY EVENINGS

London's only Showboat paddle-steamer offers you gay evenings of music, dancing, fun, and the finest in food and drinks! Everything you want for an exciting, memorable evening out ... on QUEEN OF THE SOUTH, Europe's finest pleasure steamer! Departures, Tower Pier 8.45 p.m. returning at 11 p.m. ... a whole evening aboard this enchanting ship. Drink in one of the bars, dine in splendid surroundings, stroll the decks, listen to the music or dance the evening away. This is a really romantic experience in a traditional 'riverboat' atmosphere.

Inclusive Ticket for Cruise with Sumptuous Dinner . . . 32/6

Inclusive Cruise with Buffet Supper . . . 27/6

MUSIC! DANCING! FUN! LICENSED BARS! LAVISH MENUS!

EARLY BOOKINGS STRONGLY ADVISED

COASTAL STEAM PACKET CO. LTD.

52 Crutched Friars, City of London, E.C.3.

Tel: ROYal 0281-4 Telex: 22472

Managers: A. E. Martin & Co. Ltd.

Handbill advertising showboat-style evening cruises during 1967. The company provided everything that you would require for such a cruise, but unfortunately, mechanical factors as well as lack of customers meant they couldn't save the steamer.

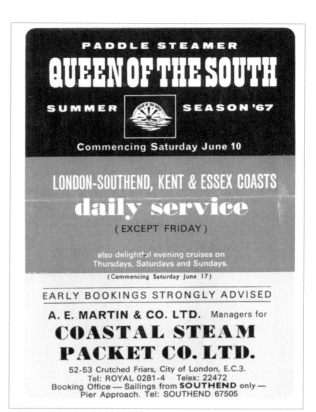

Queen of the South's brochure for 1967. The brochure showed that her owners were keen to do everything to make her viable. Traditional London fare of cockles, mussels and shrimps were offered in a seafood bar and people could dance to the 'Melotrone'.

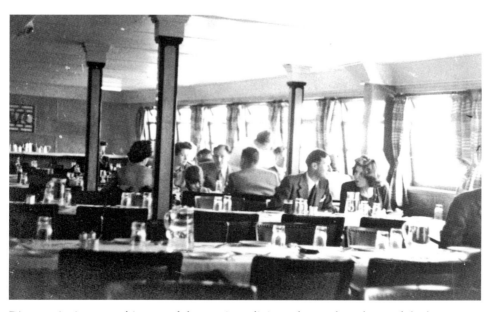

Diners enjoying a meal in one of the spacious dining saloons aboard one of the large post-war motor ships.

Delightful Day Cruises

from the

HEART OF LONDON

AN opportunity to see the historic Thames, the shipping of the world and the fascinating scenes along London's River.

The exhilaration, the fresh air and sunshine of a sea voyage are experienced without leaving sheltered waters.

A Leisurely Day

There is no need to rise at dewy dawn and risk indigestion. If it is to be a day of leisure, one should have breakfast on the Steamer.

A Family Affair

For children, a cruise on an Eagle Steamer is education without tears! a sugared pill of geography, commerce, seamanship, and history which makes a strong appeal to young and old.

A West End Restaurant Afloat

As the morning passes a cocktail may be indicated, or if the tang of salt air has produced a deeper thirst, "something larger" off the ice. A good appetite awaits upon one for lunch. A grill, table d'hote, or à la carte? ; a simple problem, but one that is given careful consideration on the Eagle Steamers. The catering on these vessels is in the efficient hands of one of the company's officials who draws upon practical experience gained in ocean liners, and exclusive West-End Restaurants and Hotels.

The Cruising Season

Eagle Steamers sail daily, except Fridays, from May to September, from Tower of London Pier, two minutes' walk from Mark Lane Underground Station and thus within easy reach of all parts of London.

Come with us — you will be delighted !

Page Sixty-eight

Advertisement from the 1937 Coronation *Eagle & Queen Line* brochure. It promotes the relaxed and stylish service offered by the fleet. It was a time when the more traditional facilities of steamers such as the *Golden Eagle* and *Crested Eagle* were joined by more modern facilities of steamers such as the *Royal Sovereign* that entered service at the time.

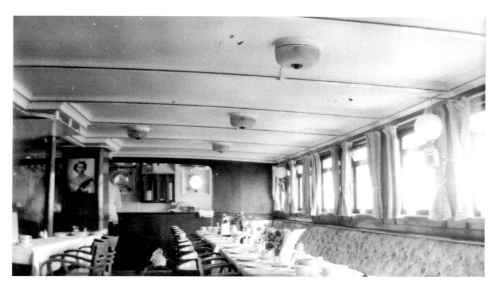

The popular dining saloon of the *Medway Queen* in 1962. This saloon changed very little during the lifetime of the steamer and traditional meal service was continued right up until the end in 1963.

THE NEW MEDWAY Steam Packet Co., Ltd. Registered Office: 365 HIGH STREET, ROCHESTER.	No. of Persons.		
Breakfast			
Hot Lunch			
Cold Lunch			
Sweets			
Coffee			
Biscuits and Cheese			
Meat Tea			
Plain Tea			
Fish			
Pot of Tea			
Bread and Butter			
Cakes and Pastries			
Salad			
Jam			
Oxo			
Dinner			
Sundries			
146855	£		

Served by

PLEASE PAY AT CASH DESK

Waitress pad used aboard the *Medway Queen* during the 1950s. The *Medway Queen* had a pleasant and comfortable dining saloon that was dominated in later years by a painting of the newly crowned Queen Elizabeth II. The company motto of the Queen Line was 'Efficiency, Comfort and Courtesy'.

55

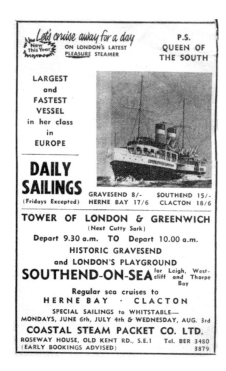

Newspaper advertisement for the *Queen of the South* during the mid-1960s. Don Rose was the main figure behind the steamer and ran the operation from his business premises in South East London. The steamer called at Whitstable as well as Herne Bay in Kent.

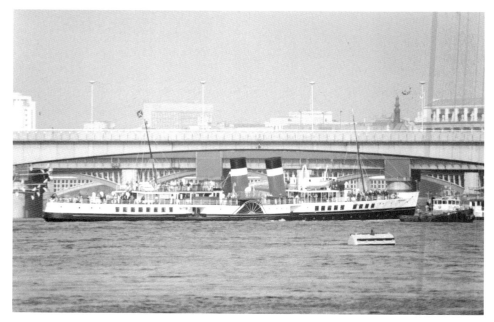

Waverley turning in the Pool of London around the 1990s. Paddle steamers have trouble in moving in places such as the Pool of London. *Waverley* needs assistance from a tug to enable her to turn around for her trips to the Kent coast. Tower Bridge is the last bridge that can be navigated by *Waverley* on the River Thames.

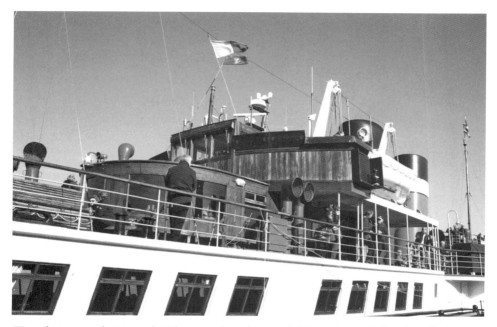

Waverley's annual visit to the Thames takes place each September and October. Cruises are offered as far as Harwich, Southwold, Margate, Whitstable and Southend.

2012 was Diamond Jubilee and London Olympics year and was a massive year of celebration in London. The Thames marked these events with a number of new attractions. These included the cableway at North Greenwich (seen here), the restoration of the *Cutty Sark*, the walkway on top of the O2 Dome and the new LED lighting on Tower Bridge.

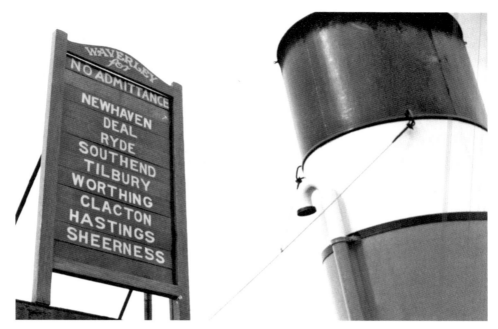

The world-famous *Waverley* spent the first part of her career on the Firth of Clyde. After withdrawal, she started her preservation career in 1975. *Waverley*'s annual Thames season is an eagerly awaited event each year for her fans. Here, her famous destination fan board lists some of the wide-ranging destinations on one of her first trips to the area.

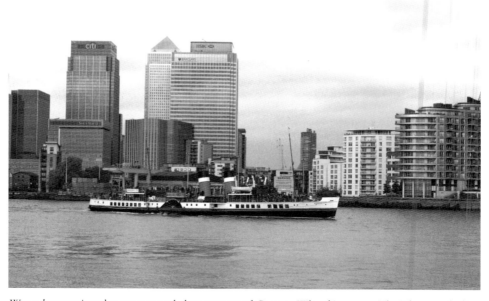

Waverley passing the towers and skyscrapers of Canary Wharf in 2010. The Thames skyline has changed dramatically over recent years, especially in the areas that were once the old London docks.

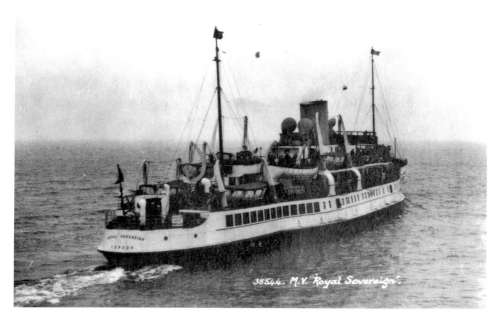

Early in the construction of the pre-war *Royal Sovereign*, alterations were made to increase passenger accommodation by using side 'blisters' in the hull. These can be clearly seen in this image.

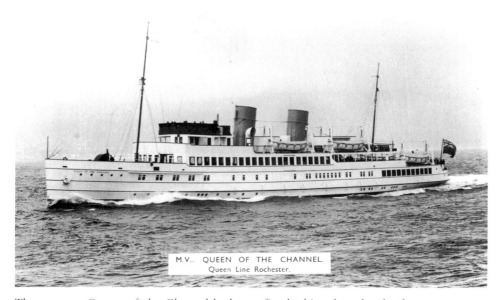

The pre-war *Queen of the Channel* had two fine-looking funnels (the front one was a dummy). She was totally unlike any other steamer that had plied the Thames. Her white hull and cream-coloured funnels further emphasised the new look. She was a Queen Line steamer.

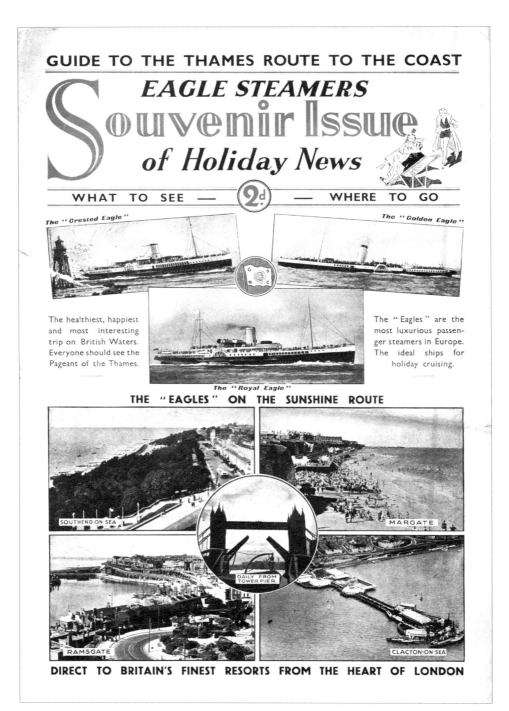

GUIDE TO THE THAMES ROUTE TO THE COAST

EAGLE STEAMERS

Souvenir Issue

of Holiday News

WHAT TO SEE — 2d — WHERE TO GO

The "Crested Eagle"

The "Golden Eagle"

The healthiest, happiest and most interesting trip on British Waters. Everyone should see the Pageant of the Thames.

The "Eagles" are the most luxurious passenger steamers in Europe. The ideal ships for holiday cruising.

The "Royal Eagle"

THE "EAGLES" ON THE SUNSHINE ROUTE

SOUTHEND-ON-SEA

MARGATE

DAILY FROM TOWER PIER

RAMSGATE

CLACTON-ON-SEA

DIRECT TO BRITAIN'S FINEST RESORTS FROM THE HEART OF LONDON

Eagle Steamers produced a fine newspaper that was sold aboard its steamers during the 1930s. It included numerable illustrated articles to entice the visitor to visit each Kent resort.

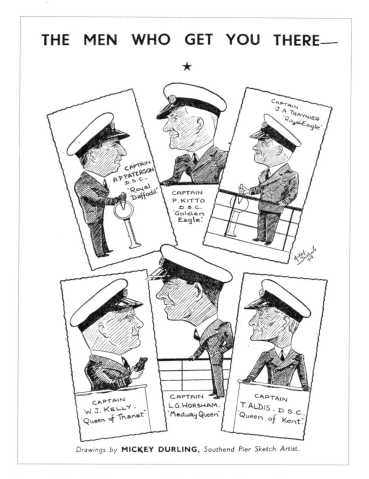

THE MEN WHO GET YOU THERE—

★

CAPTAIN A.P. PATERSON D.S.C. "Royal Daffodil"

CAPTAIN P. KITTO D.S.C. "Golden Eagle"

CAPTAIN J.A. TRAYNIER "Royal Eagle"

CAPTAIN W.J. KELLY "Queen of Thanet"

CAPTAIN L.G. HORSHAM "Medway Queen"

CAPTAIN T. ALDIS D.S.C. "Queen of Kent"

Drawings by **MICKEY DURLING**, Southend Pier Sketch Artist.

'Eagle & Queen Line' Masters and their War Record

Captain Paterson DSC (*Royal Daffodil*) initially helped to evacuate 4,000 children from London to Lowestoft. He later helped to rescue 8,000 troops from Dunkirk. He was her master throughout the war, during which she steamed 170,000 miles and carried 2,443,979 passengers.

Captain Kitto DSC (*Golden Eagle*) helped to evacuate children aboard the *Queen of the Channel*. He later joined the RNR and commanded *Queen of Thanet* on Thames and North Sea patrols.

Captain Traynier (*Royal Eagle*) initially helped to evacuate 3,000 mothers and children from Dagenham and Tilbury. He later was with the RAF in *Golden Eagle* on the River Sheldt and at Antwerp maintaining balloon barrages.

Captain Kelly (*Queen of Thanet*) initially served on the GSNC freight ships and was later engaged to carry petrol and army stores to France after the invasion.

Captain Horsham (*Medway Queen*) joined the RNR and served two and a half years on minesweepers. He later joined the Hamburg Naval Party and remained in Germany until December 1945.

Captain Aldis DSC (*Queen of Kent*) initially carried evacuees from London to the East Coast. He took part in the Dunkirk evacuation and bought back 20,000 troops. He later assisted in the assembly of the Mulberry Harbours.

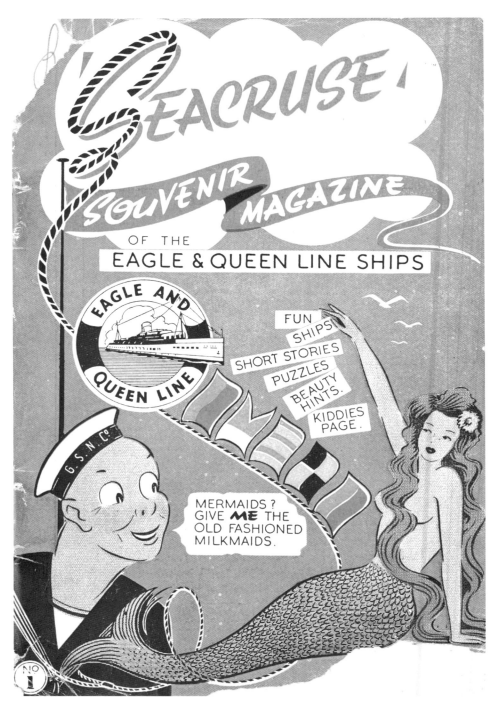

In the days before iPods and Kindles, passengers on cruises to the Kent coast would enjoy the puzzles, jokes and stories included in magazines such as *Seacruse*. The post-war steamers also proudly announced that they had a telephone for passengers and that the news and music would be relayed over the tannoy during the cruise.

9. *Royal Eagle* departing from London around 1932. In 1931, the GSNC placed an order for a new paddle steamer. Whilst being constructed, the company asked the public to suggest a name for the new steamer. *Royal Eagle* was of course chosen.

10. The Cocktail Bar aboard the Royal Eagle during the 1930s. Despite being a modern paddle steamer, Royal Eagle had this Mock-Tudor style bar. Facilities like this were always popular on the way to Margate!

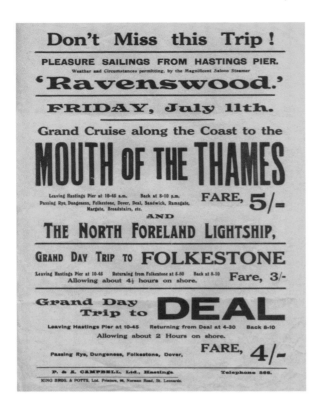

11. As well as offering cruises from the various Kent resorts, they also welcomed passengers from Sussex piers. This handbill from 1914 lists cruises from Hastings Pier. P & A Campbell operated an impressive fleet of sleek, white-funnelled paddle steamers from Sussex to Kent as well as to the Isle of Wight and Hampshire.

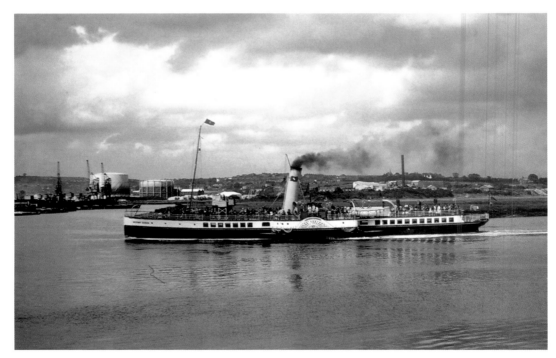

12. A splendid-looking *Medway Queen* close to Sun Pier on the River Medway on 31 August 1963.

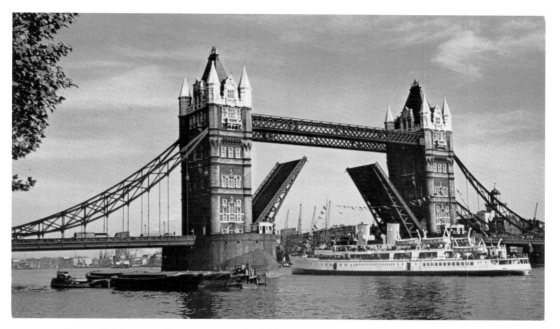

17. Tower Bridge cost £1,500,000 to build between 1886 and 1894. In 1950, the bridge would lift around 3,000 times a year. By 2012, the number of bridge lifts had decreased to 1,000.

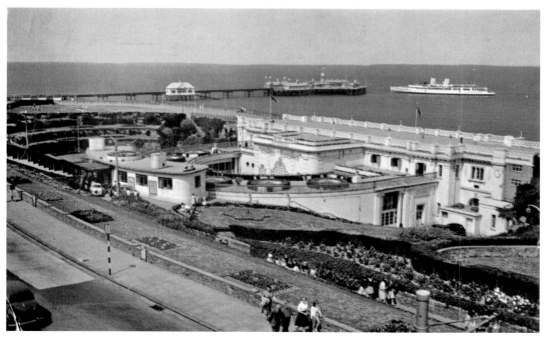

18. *Royal Daffodil* approaching Margate Jetty during the early 1960s. In the foreground is the Winter Gardens. The entertainment complex was opened on 3 August 1911 and initially provided mainly orchestral entertainment. From the 1920s, summer season entertainment was offered and was very popular with those arriving by pleasure steamer for holidays at Margate.

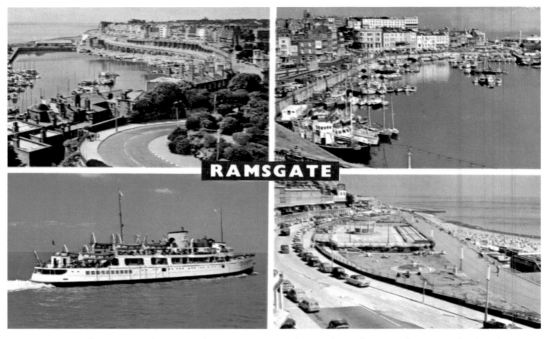

19. *Royal Sovereign* departing from Ramsgate. The Eagle Café was a favourite facility for pleasure steamer passengers arriving at the harbour wall for many years and was run by Reg Booth. It provided a panoramic view of the harbour and town and housed the port control offices on the top. The nearby berthing decks still exist and show the facilities that existed in the post-war heyday of the steamers.

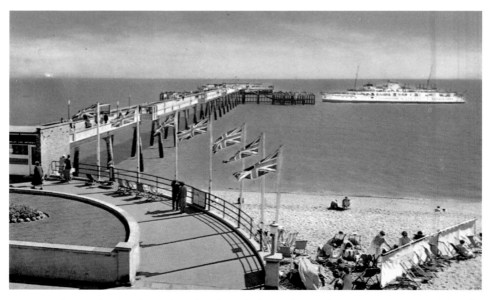

20. The pier head at Deal has three landing platforms for use by pleasure steamers. Funnily, the bottom level was never accessible due to a miscalculation. By the start of the twenty-first century, the pier was showing signs of age and a £3 million restoration project was completed between 2002 and 2004.

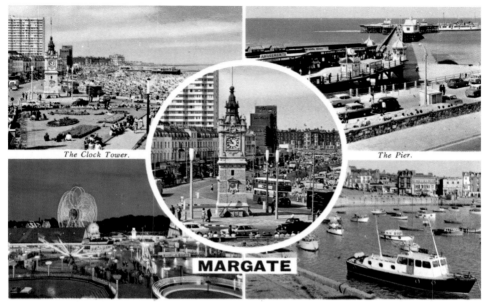

The Clock Tower. The Pier.

MARGATE

" Dreamland." The Harbour.

21. Margate was still hugely popular until the 1960s, when these photographs were taken. The tradition of taking an annual trip to Margate was common to many families from London and Essex. The most popular attraction for daytrippers was always Dreamland.

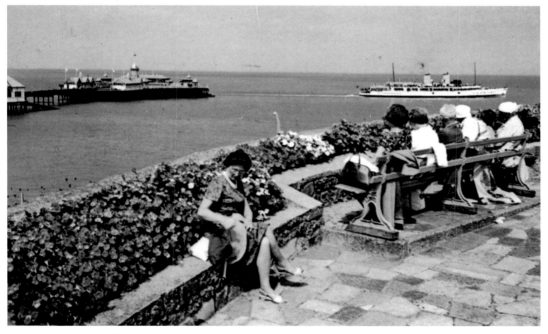

22. *Royal Daffodil* departing from Margate Pier around 1962, viewed from the vicinity of the Winter Gardens. The *Royal Daffodil* and her sisters were perhaps best known for their cruises to Margate. Once London and Southend passengers had been disembarked they then boarded more passengers for short cruises along the Kent coast or to France.

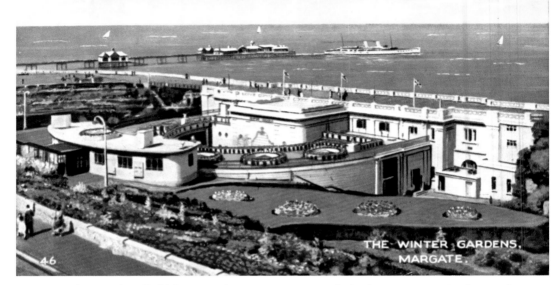

23. The *Royal Daffodil* departing from Margate Pier with the famous Winter Gardens in the foreground. During the time of the evacuation of Dunkirk, Dreamland became an important centre for those rescued from the beaches. The cafés became giant hospitals and the ballroom was used for servicemen to sleep in. There was also an interrogation centre set up in the Garden Café as it was thought that spies would try to infiltrate the UK though the evacuation.

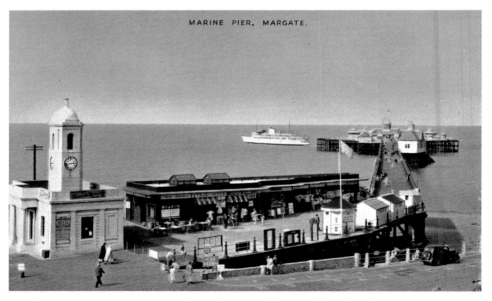

24. *Royal Sovereign* departing from Margate. Margate Pier (or Jetty as it was more commonly known) was the most famous Kent pier. The first landing structure at Margate dated back to 1808 but it was the 'Pier King' – Eugenius Birch – that designed the first pier between 1853 and 1857. Altogether, he designed some fourteen piers around the coastline of the UK. The pier at Margate was the first to be constructed of iron. It was also the very first to have screw piles to attach its massive legs to the seabed.

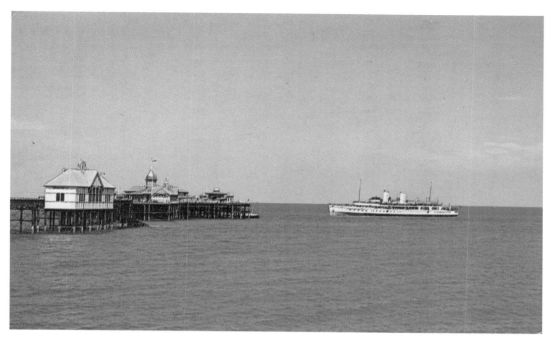

25. *Royal Daffodil* appoaching Margate Jetty during the late 1950s. *Royal Daffodil* was perhaps the best loved pleasure steamer of the post-war years.

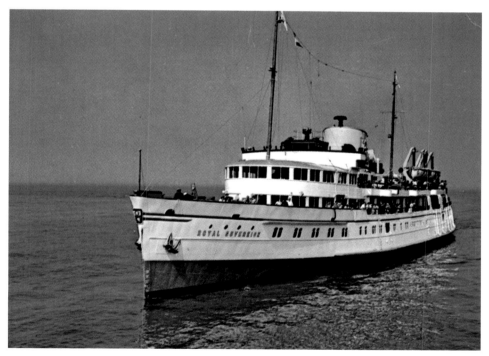

26. The *Royal Sovereign* was the longest lived of the post-war GSNC motor ships and survived until the twenty-first century. She was, though, heavily converted after being withdrawn in 1966.

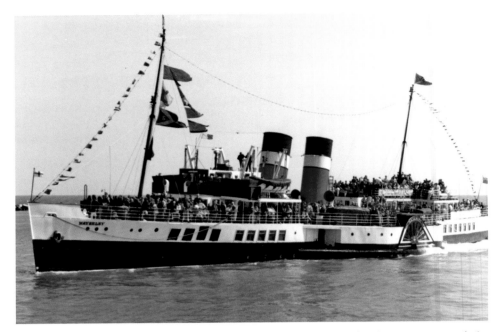

27. One of *Waverley's* best trips was to commemorate the fiftieth anniversary of the Dunkirk evacuation in May 1990. She accompanied many of the Dunkirk little ships to and from the coast of France. The house-flags of the steamer companies that sent ships to Dunkirk were flown from her mast on the day.

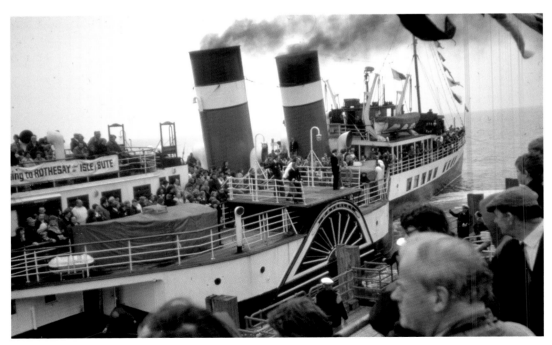

28. Huge crowds awaited the *Waverley* when she visited Deal Pier in 1978. The queue to board her reached the full length of the pier. This was *Waverley's* first season on the Thames.

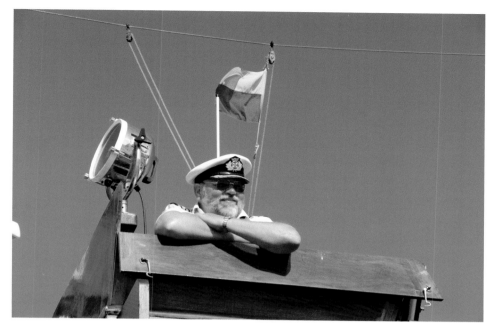

29. Captain Ian Clarke has been *Waverley* and *Balmoral*'s popular and skilled master on the Thames since 2008. Captain Clarke also lives in Kent and so is particularly well suited to taking his command to the many harbours and piers of his home county. He first experienced the Thames as a cadet in 1968 and first went under Tower Bridge on HMS *Scarborough* in 1973.

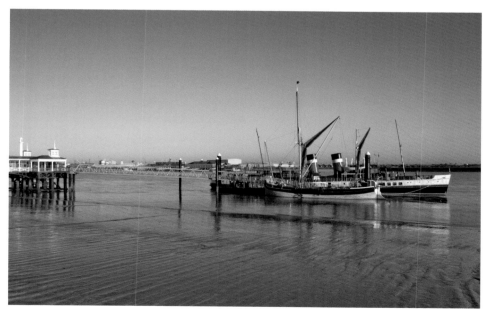

30. Gravesend's Town Pier was used until the mid-1960s by the Gravesend to Tilbury passenger ferry. When the ferry transferred to the West Street Pier the Town Pier became almost derelict until it was restored by Gravesham Borough Council in 2002. *Waverley* is seen alongside the Town Pier here in 2012.

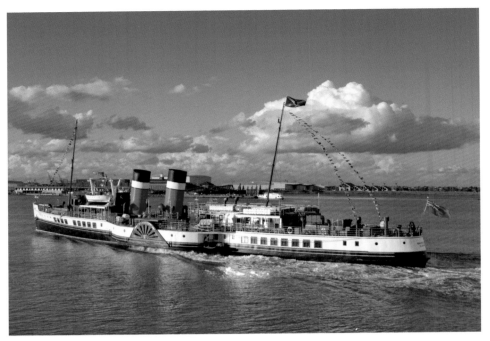

31. *Waverley* departing from Gravesend for London in October 2012. The first steamer started to ply between London and Gravesend in 1815. Over the next decade, this brought a lot of prosperity to Gravesend and further paddle steamer services developed. The arrival of *Waverley* in 2012 heralded a new era of paddle steamer services.

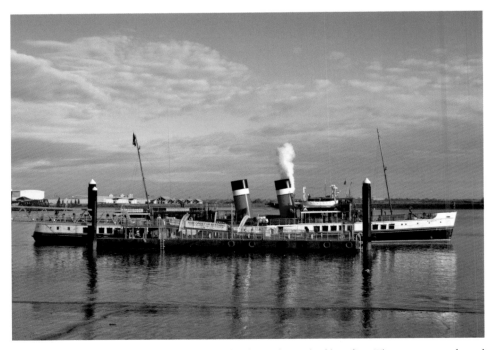

32. *Waverley* giving three blasts on her whistle at the end of her first Thames season based at Gravesend in 2012. After leaving, *Waverley* departed for the winter at Glasgow.

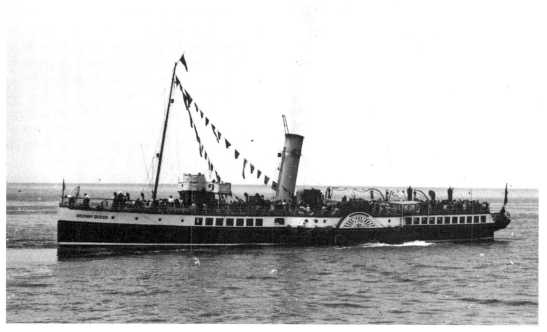

Medway Queen made several appearances in films during her career. These included *Dunkirk* and *French Dressing*.

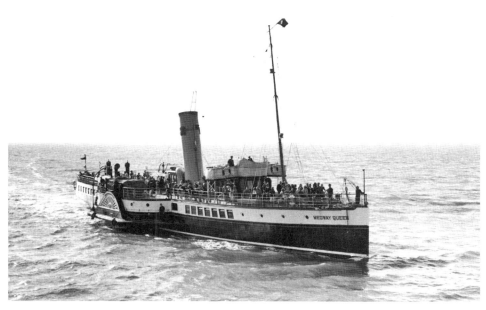

Medway Queen towards the end of her career. During the mid-1930s, the Queen Line offered regular services to Southend and East Coast resorts from Strood Pier, Sun Pier and Gillingham Pier.

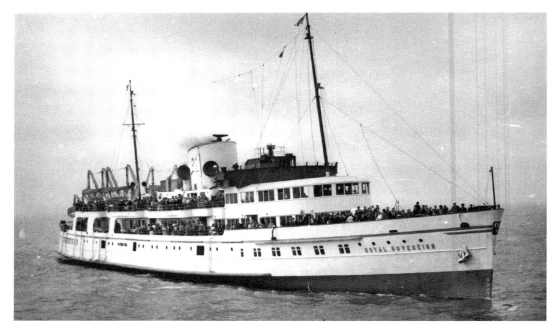

At the end of the Second World War the GSNC placed an order with Denny of Dumbarton for a replacement vessel for the sunken *Royal Sovereign*. The new steamer was launched on 7 May 1948 and completed her maiden voyage on 24 July 1948, sailing from Tower Pier, London to Ramsgate.

The famous Denny-built *Royal Sovereign* viewed from the Dunkirk veteran *Medway Queen* on a visit by the *Medway Queen* to the River Thames.

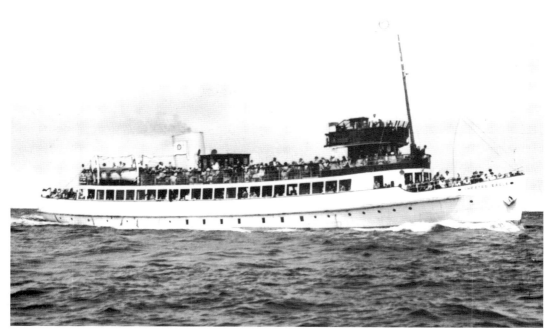

Crested Eagle was built in 1938 by J. Crown & Sons of Sunderland. She was 138 feet in length and provided popular cruises for the Eagle Steamers from places such as Gravesend during the 1950s.

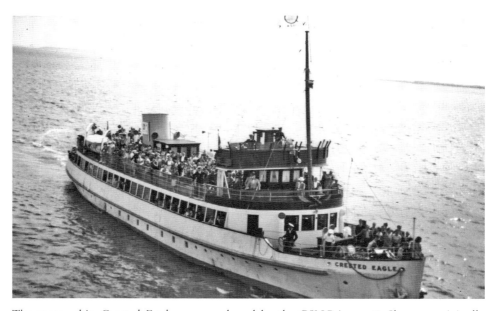

The motor ship *Crested Eagle* was purchased by the GSNC in 1948. She was originally built as the *New Royal Lady* in 1938 for service at Scarborough. In 1948/9 she operated the London Tower Pier to Gravesend service. She was later based at Ramsgate for a while.

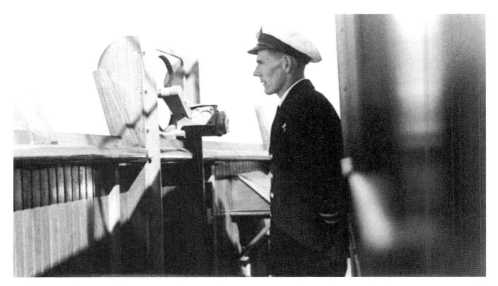

Officers and crew often returned year after year to work on the GSNC pleasure steamers. It was normal for many to remain with the fleet for their entire careers. Many officers worked on the company's coastal steamers during the winter, whereas many of the crew worked in hotels. The GSN had their stores, depot and fitting-out yard, known as 'The Stowage', at Deptford Creek. The company bought this land in 1825 and kept it until the 1970s. It has now been cleared and redeveloped for luxury apartments.

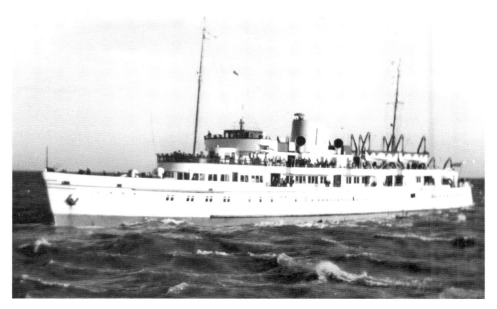

Queen of the Channel (seen here at Ramsgate) and *Royal Sovereign* looked very similar. They can be quickly identified by the sun lounge below the wheelhouse. On the *Royal Sovereign* this is enclosed on two levels. On the *Queen of the Channel*, it is enclosed on one level with an open deck above with angled glass screens.

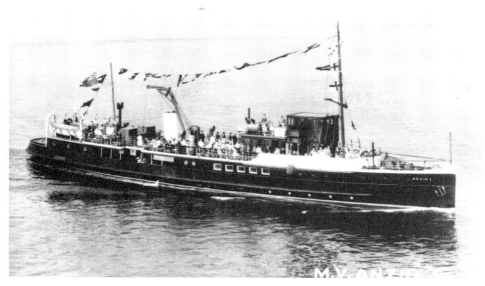

The *Anzio I* is now more-or-less forgotten. She had a very brief career on the Thames and was well known for her ferry service between Sheerness and Southend.

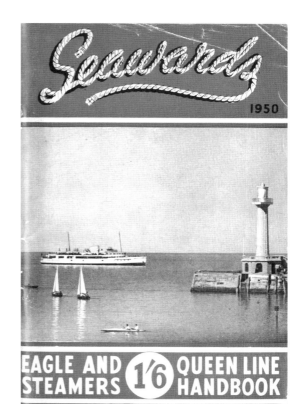

Cover for *Seawards*, the handbook produced by the Eagle & Queen Line in 1950 to give passengers essential information to enjoy their cruise to the Kent coast. The cover shows the *Royal Sovereign* approaching Margate with the old stone pier on the right.

When withdrawn in 1949, *Royal Eagle* was in excellent condition. The GSNC had hoped that she could be sold for further service elsewhere. She finally went to the breakers just a few years later.

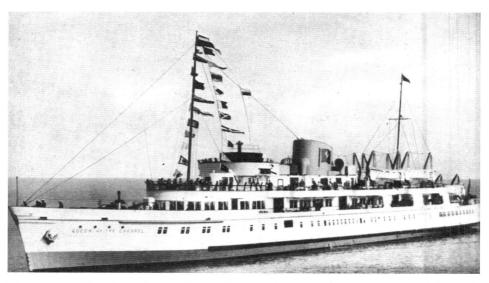

The *Queen of the Channel* around 1949. In 1950, the seven pleasure steamers of the Eagle & Queen Line fleet could carry up to 9,313 passengers at any one time. The combined tonnage was 7,802. *Queen of the Channel* was the smallest of the three motor ships.

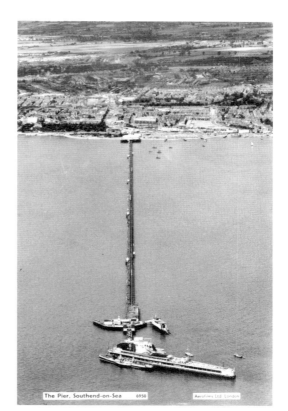

Queen of Kent alongside Southend Pier. Southend was always an important calling point for pleasure steamers travelling to and from Kent. By the 1930s, the Prince George Extension offered extensive berthing facilities for the steamers. A decade after the Eagle Steamers were withdrawn, buildings on the pier head were destroyed in a massive fire in 1976.

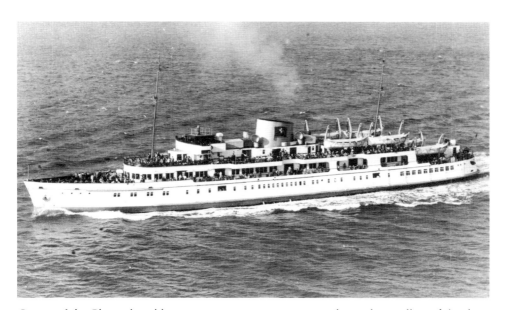

Queen of the Channel could carry up to 1,536 passengers and was the smallest of the three post-war GSNC motor ships. She was 41 feet shorter than the *Royal Daffodil* and carried around 800 less passengers.

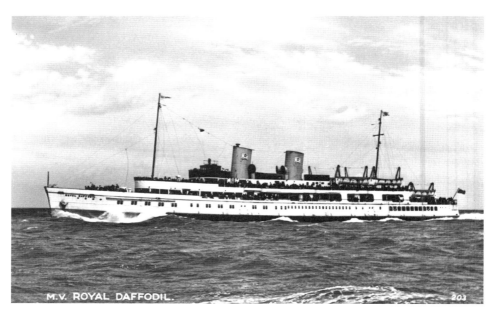

M.V. ROYAL DAFFODIL.

Royal Daffodil was built by the world-famous Denny of Dumbarton. This company built the finest pleasure steamers that ever served the UK coastline. She could carry up to 2,385 passengers and she had a length of 313 feet. The large passenger capacity was wonderful when weather and economic conditions were good, but in leaner times she was uneconomic.

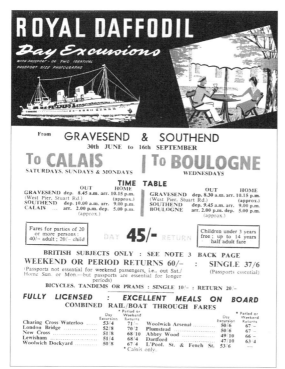

The Eagle Steamers programme for 1962. During that year, the *Royal Sovereign* offered cruises from London to Margate while the *Royal Daffodil* offered cruises from Gravesend to Margate, Deal and the 140-mile round cruise to the French coast.

3
Margate's Pleasure Steamers

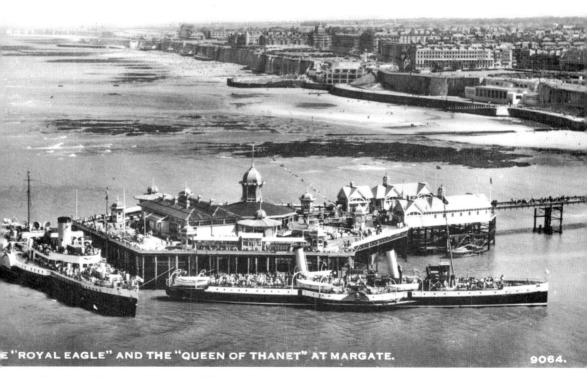

E "ROYAL EAGLE" AND THE "QUEEN OF THANET" AT MARGATE. 9064.

The *Royal Eagle* and *Queen of Thanet* alongside Margate Jetty around 1935. The pier head provided excellent facilities for those leaving or joining the steamers. It also gave those in deckchairs a grandstand view of the ever-changing hustle and bustle of steamer arrivals and departures. Shore-based entertainments can also be viewed in this postcard, such as the Winter Gardens and the Lido.

Glen Rosa at Margate. This steamer was sold for Thames service during the 1880s after service on the Firth of Clyde at Arran. She provided cruises along the Kent coast for several owners as well as cruises to Boulogne, Calais and Dunkirk.

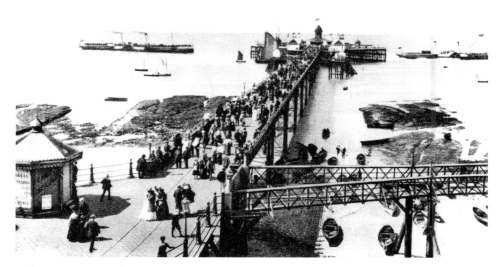

Koh-i-Noor approaching Margate Pier. This steamer was massive and was over 300 feet in length. She cost over £50,000 to build and was named after the famous jewel. For a long time she was well known for her Tilbury to Margate cruises. She was cut up after the First World War.

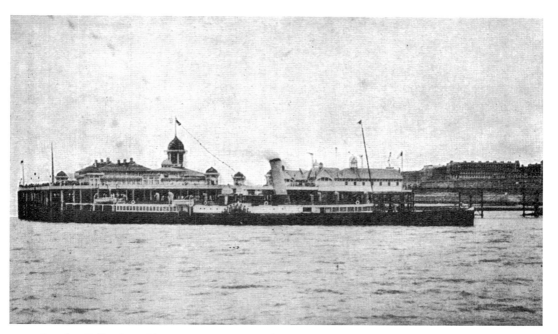

London Belle alongside Margate Pier around 1925. Belle Steamers ran popular trips to the English Channel from the resort. One of the most popular of these was to the Goodwin Sands. Another favourite trip was to the Tongue or the Gull lightships off Deal.

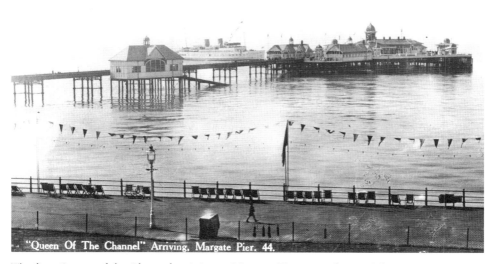

The first *Queen of the Channel* arriving at Margate Pier around 1938. This steamer was one of a new breed of Thames pleasure steamer and was built by Denny of Dumbarton. Sadly, she was lost during the Second World War.

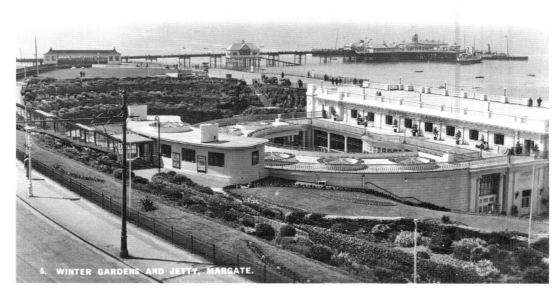

5. WINTER GARDENS AND JETTY, MARGATE.

The famous Margate Winter Gardens and the equally famous jetty with pleasure steamers alongside it around the 1930s.

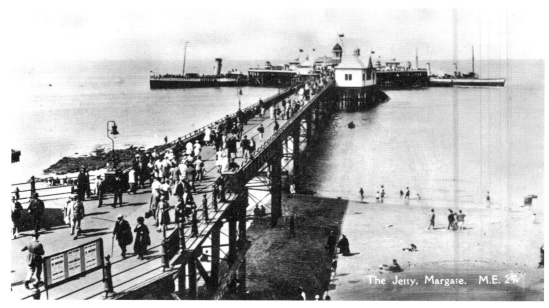

The Jetty, Margate. M.E. 24

The jetty at Margate around the mid-1930s with the *Golden Eagle* and one of the two converted ex-minesweepers from the First World War alongside the landing stage. Margate Jetty provided excellent landing facilities for passengers from London. A quick turnaround of passengers was required to enable maximum profits to be made.

QUEEN LINE STEAMERS

FIRST BOOKING OFFICE MARGATE PIER AND ON RIGHT AT PIER HEAD.

SPECIAL TRIPS from MARGATE PIER

Throughout the Season, from JUNE 22nd, 1935
(Weather and other circumstances permitting)

BY EUROPE'S LATEST SUPER - LUXURY LINER

"QUEEN OF THE CHANNEL"

(DIESEL-ENGINED TWIN-SCREW VESSEL) 1,100 TONS

TO

On Saturdays and Mondays	**OSTEND**	Leaving at 10.10 a.m.

Adult 10/6 Day Return Child (under 14) 5/6

On Tuesdays	**BOULOGNE**	Leaving at 10.45 a.m.

Adult 10/- Day Return Child (under 14) 5/6

On Sundays & Thursdays	**CALAIS**	Leaving at 11.30 a.m.

Adult 8/9 Day Return Child (under 14) 5/-

Allowing about 2½ hours in OSTEND	Arriving back at Margate from Ostend 7.0 p.m.
,, ,, 3 ,, ,, BOULOGNE	,, ,, ,, ,, ,, Boulogne 6.45 ,,
,, ,, 3½ ,, ,, CALAIS	,, ,, ,, ,, ,, Calais 6.45 ,,

NO PASSPORTS REQUIRED. SPECIAL TERMS TO PARTIES.

First-Class Catering and all Refreshments at Popular Prices.

DO NOT MISS THE OPPORTUNITY OF VISITING FRANCE AND BELGIUM BY THE FINEST VESSEL OF HER CLASS AFLOAT

THE LONDON & SOUTHEND CONTINENTAL SHIPPING Co., Ltd.,
in conjunction with
THE NEW MEDWAY STEAM PACKET CO., LTD.

The Queen Line

W. S. GABRIEL (Agent) Margate & Ramsgate. Phone : Margate 1430

IMPORTANT NOTICE.—Passengers to France and Belgium must be British, French or Belgian subjects or they will not be permitted to land there. Passengers having gone ashore are not allowed on board again until half an hour before the advertised time of sailing. No luggage, dogs or bicycles allowed on day trips to France or Belgium. Fares include Continental landing tax. If at any time, for any reason, the Company's vessel does not complete the journey to destination, passengers will be charged an amount proportionate to the distance covered. The charge for Sun Deck is 1/- extra each way.

NOTE — The time for passengers to re-embark for Return Journey is always announced on arrival at the Continental Port.

Head Office : 365-367 High Street, Rochester. Tel. Chatham 2204-5. S. J. SHIPPICK, Managing Director

Cooper, Printer, Margate

One of the first handbills for the first of the Thames motor ships from Margate Jetty in 1935. It's interesting to note that the *Queen of the Channel* was described as a 'Super Luxury Liner'. Captain Shippick and the Queen Line always marketed their steamers well.

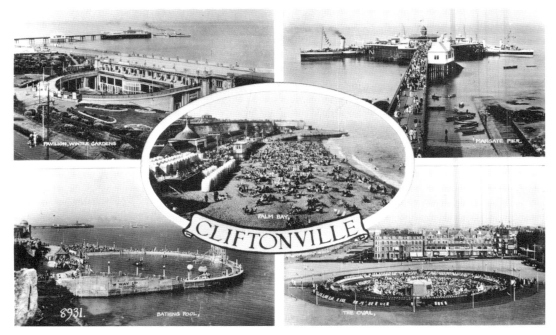

Cliftonville is adjacent to the main town of Margate. It provided a number of sedate facilities for daytrippers and holidaymakers from the Eagle Steamer fleet. It could be easily reached from the jetty.

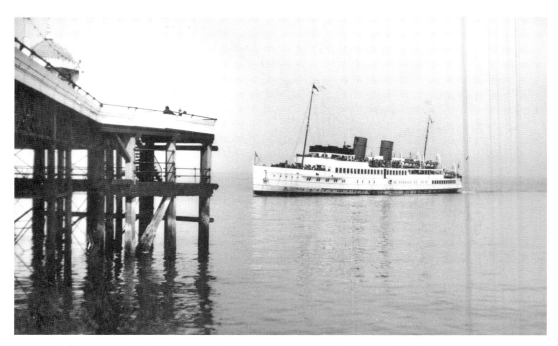

The first motor ship, *Queen of the Channel*, approaching Margate Pier in 1936.

THE THREE STAR LINE

THE TWIN SCREW TURBINE STEAMER

"LADY ENCHANTRESS"

– THE FIRST CLASS PULLMAN COMFORT SHIP –

DAILY

Weather and other circumstances permitting

FROM SOUTHEND PIER AT 9.30 A.M. TO

MARGATE

Allowing about 5 HOURS ASHORE

DUE ON RETURN TO SOUTHEND. AT 8 P.M.

☛ A Grand 3 Hour Cruise each way !

☛ A Good Time Ashore !

Excellent Catering and all kinds of Refreshments on board at Popular Prices _____ Fully Licenced

TRAVEL FIRST CLASS AT EXCURSION FARES

ADULT DAY RETURN **10/-** Sundays or Bank Holiday
No Extra Charge for Sats.,
No Extra Charge for Sun Deck

UNDER 14 HALF FARE

BOOK at the Three Star Line Offices, Pier Hill and at Pier Head
SOUTHEND

| Please see separate Bills for particulars of Special Channel Cruises |

THE THREE STAR SHIPPING CO. LTD. Head Office: Ramsgate. Phone: 1212.
Local Phone : Marine 67945

Printed by W. H. Houldershaw. Ltd. 49-55. London Road, Southend-on-Sea.

Lady Enchantress was purchased from the Admiralty in 1946 for £22,500 but refit costs ballooned to over £200,000, making the venture far from economic. Her first cruise from Gravesend to Margate was on 4 August 1947. Despite the initial post-war boom in Thames services, the still-mighty GSNC was able to provide opposition. Just six weeks later, she had lost the fight and was withdrawn from service.

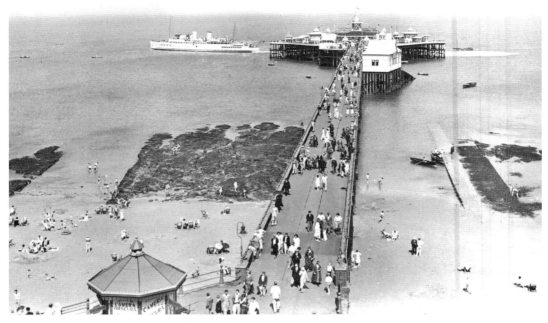

The pre-war *Queen of the Channel* departing from Margate Jetty in the late 1930s.

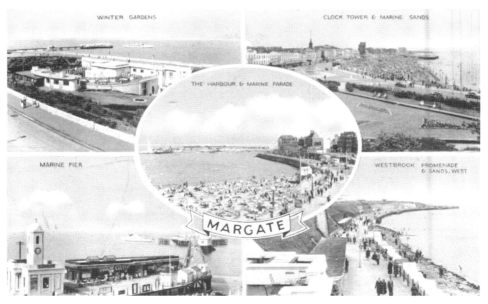

The Royal Daffodil was a frequent visitor to Margate throughout her career. She had two four-blade propellors of 8 feet 6 inch diameter. The Royal Daffodil consumed 165 gallons of fuel an hour. Her tanks could carry 16,000 gallons of fuel.

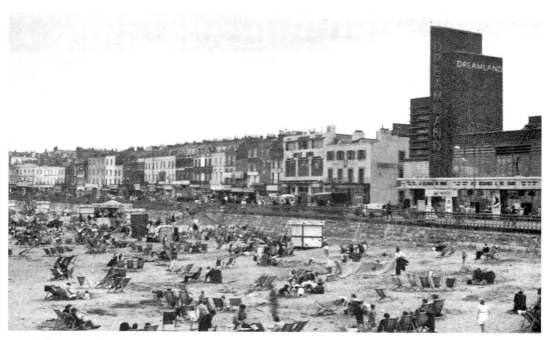

The Dreamland amusement park was a popular magnet for most pleasure steamer passengers to Margate. The 20-acre park contained such favourites as the Scenic Railway, River Caves, Caterpillar and Racing Coaster.

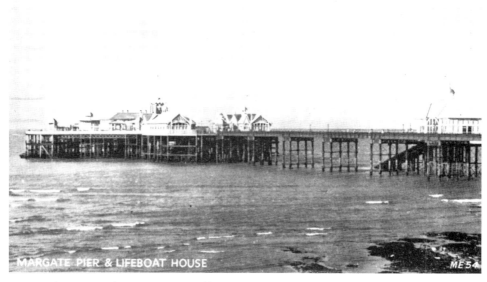

During the 1930s, the Queen Line offered a wide variety of cruises throughout Kent and to the coast. Some of these incorporated motor coaches as part of the day out. The Royal Arsenal Co-operative Society, for example, took passengers to Margate by coach and they would then transfer to steamer at the pier for Calais.

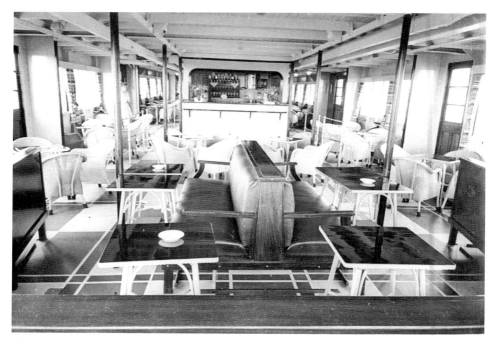

The roomy lounge and bar aboard the post-war *Queen of the Channel*. This image shows the light-drenched facilities that enabled passengers to enjoy panoramic sea views in the comfort of a lounge or bar. These steamers had greater passenger space than other steamers as they had widened hulls for this purpose.

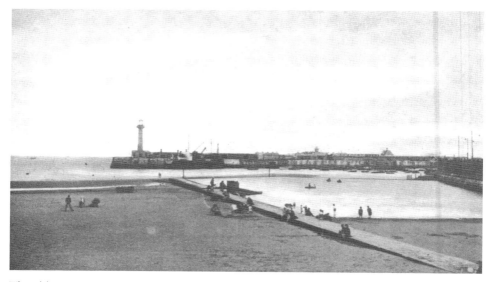

The old stone pier at Margate. This pier was an early calling point for paddle steamers to the town during the mid-nineteenth century. It was revived as a calling point for the Waverley and Balmoral during the 1990s and allows passengers to visit Margate in the traditional way.

Margate's 6 miles of firm golden sand has always been a firm favourite for trippers. It was on these sands that Benjamin Beale introduced the first bathing machines in 1753. 1930s pleasure steamer guides described Margate as one of the most healthiest spots in the UK and said that the healthiest spot in Margate was on the Margate Jetty!

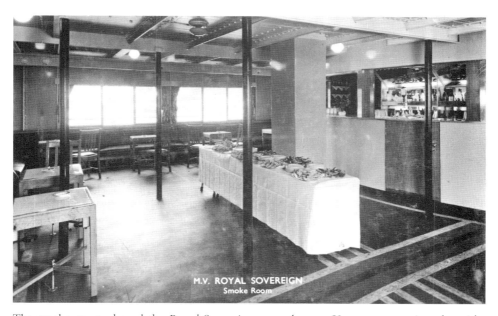

The smoke room aboard the *Royal Sovereign* around 1955. You can appreciate the wide, enclosed decks from this photograph. Areas such as this were ideal for providing buffets for the lucrative charter market. *Royal Sovereign* was a smaller sister to the *Royal Daffodil* and could carry up to 1,910 passengers.

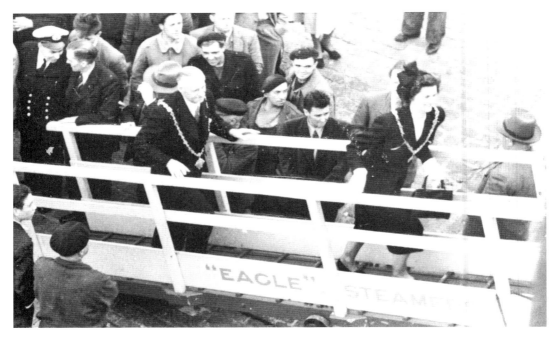

The Mayor of Margate joining the *Royal Daffodil* during the tenth anniversary commemorations of the Dunkirk evacuation. Many ex-servicemen joined the civic party to travel between Margate and France.

The famous *Royal Daffodil* was the ship that rescued the most men from the beaches at Dunkirk. She rescued a total of 7,461 men. She later took part in the tenth anniversary commemorations of the event when she undertook a special cruise between Margate and Dunkirk. Special caskets of sand were exchanged between mayors at both towns.

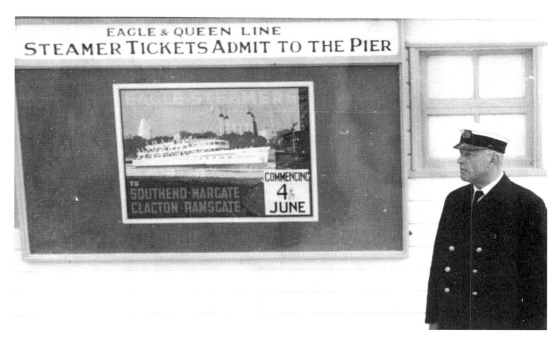

The GSNC had its origins way back in 1824 and always reigned supreme on the Thames and at Kent resorts. One of the first steamers to run between London and Margate was the *Eagle*. The theme was used right up until the end of GSNC in the mid-1960s.

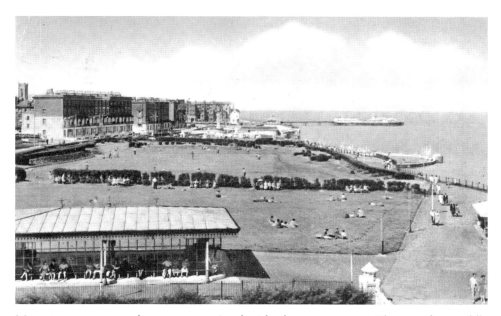

Margate was very much a town associated with pleasure steamers. The very first paddle steamers called there in the 1820s and the link thrived until the mid-1960s. For many years, over 1 million passengers a year travelled on the paddle steamers of the GSNC fleet between London and Margate.

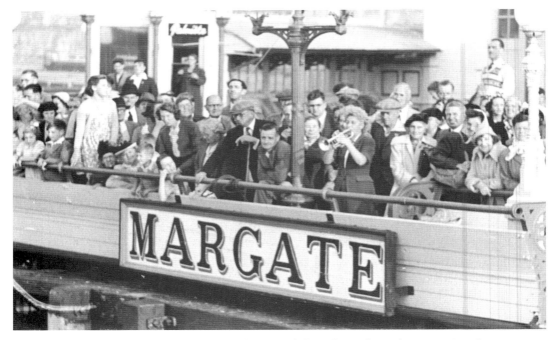

Piers, as well as the pleasure steamers that served them, have always been exciting places to view the busy scene as steamers arrived or departed on a cruise. This view of Margate Pier in 1949 shows the crowds (and trumpeter) heralding the arrival of an Eagle Steamer.

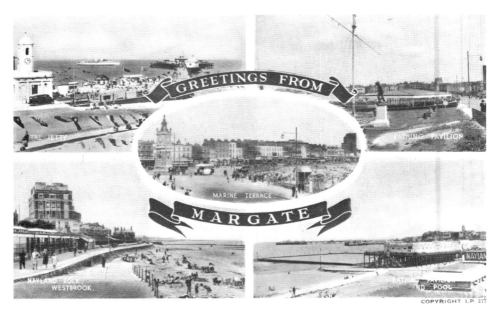

The Dreamland amusement park was a popular magnet for most pleasure steamer passengers to Margate. The 20-acre park contained such favourites as the Scenic Railway, River Caves, Caterpillar and Racing Coaster.

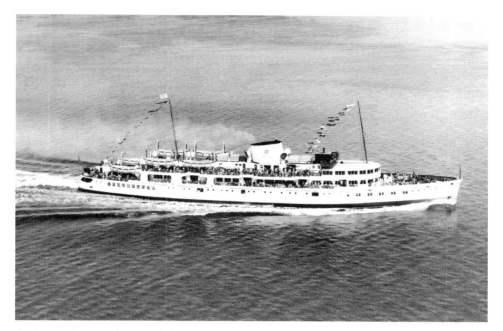

An impressive aerial view of the post-war Royal Sovereign, a well-loved steamer connected with services to Margate.

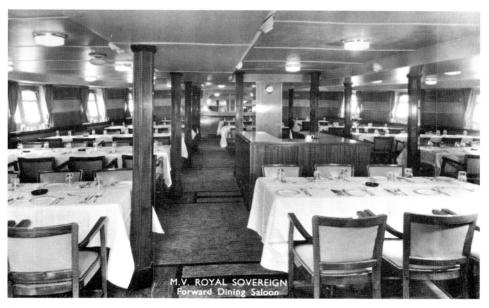

The forward dining saloon of the *Royal Sovereign* in 1955. Pleasing wood panelling in different wood veneers was used to complement the crisp linen and silver of the table settings. When the Eagle Steamers disappeared in the mid-1960s, the silver-plate and crockery was sold off to hotels and boarding houses for a few pennies or discarded. Today, these reminders of the fine dining are now very rare.

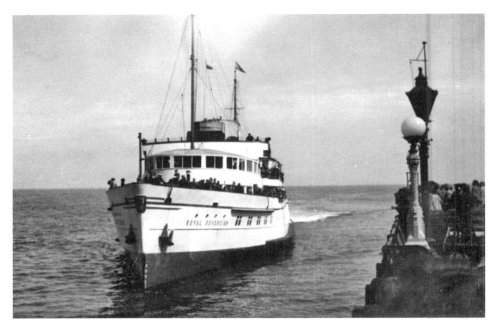

Royal Sovereign was well known for her regular cruises between Tower Pier and Tilbury, Southend, Margate and Ramsgate. She was launched on Friday 7 May 1948.

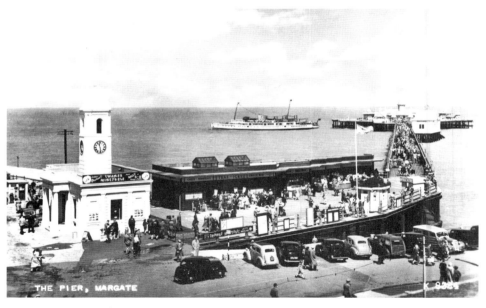

A post-war view of Margate Pier with a GSNC motor ship departing on a cruise. When the Eagle Steamers stopped the jetty gradually declined. In 2011, the Turner Contemporary Gallery was opened close to this view. The gallery has become a great success and people are now able to appreciate the views that captivated people such as J. M. W. Turner as well as countless Eagle Steamer passengers in the past.

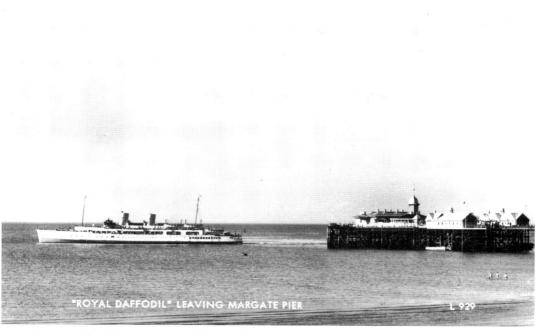

Royal Daffodil departing from Margate Jetty. The jetty was a wonderful example of Birch's skills. It was lengthened during the mid-1870s to enable a hexagonal-shaped landing platform with pavilions to be built.

Cliftonville is located to the east of Margate and contained a number of entertainment facilities that were enjoyed by passengers that disembarked from the pleasure steamers at the jetty. The largest of these was the Winter Gardens Theatre.

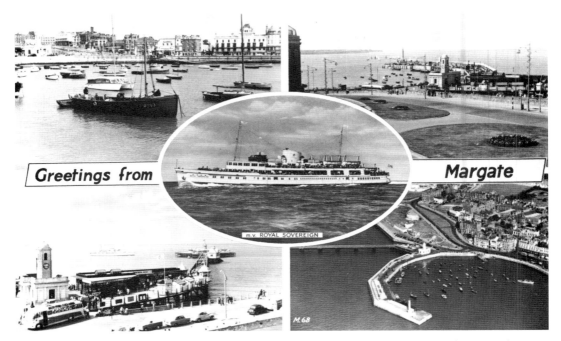

Greetings from Margate

m.v. ROYAL SOVEREIGN

M.68

Margate Jetty was used during the Second World War for ferrying troops and stores. The post-war decline led to the jetty losing some of its appeal as steamer services declined. The pier was finally closed in 1976.

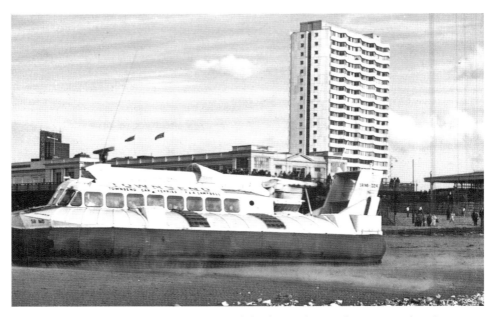

Hovercraft was seen as the sea transport of the future during the 1960s. After the GSNC left Margate in the mid-1960s, Townsend Ferries worked with Bristol Channel operators P & A Campbell to provide a hovercraft service from Margate (seen here) and Thanet resorts. Sadly, it didn't last for long.

4
Other Kentish Resorts &
Their Pleasure Steamers

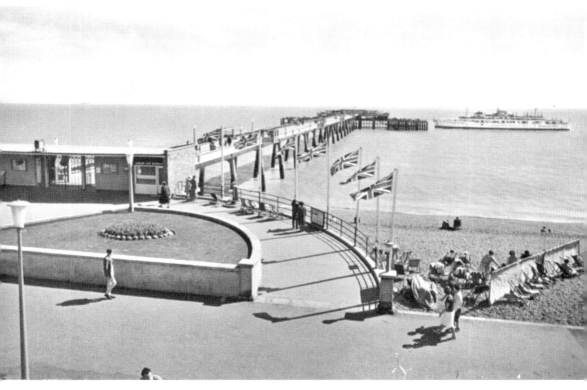

At the cessation of hostilities in 1945, a new pier for Deal was planned. A bold new pier was subsequently built from 1954 onwards by Concrete Piling Limited from reinforced concrete. It was designed by Sir William Halcrow & Partners and cost £250,000.

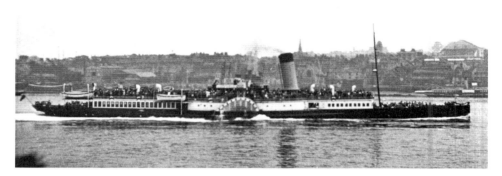

Laguna Belle passing Gravesend around the mid-1930s. Gravesend was always an important calling point for Thames pleasure steamers. During the mid-nineteenth century, Gravesend was itself a popular tourist destination but it soon declined. Above the bow of the *Laguna Belle* you will see one of the Gravesend to Tilbury passenger ferries at the Town Pier. This pier re-opened to pleasure steamer services in 2012 after many years of neglect, with visits by the famous *Balmoral* and *Waverley*.

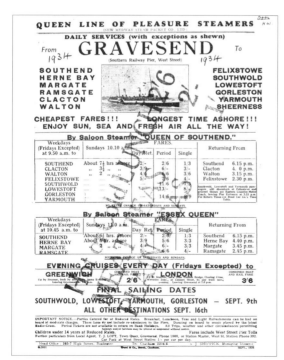

Queen Line sailings from Gravesend during the 1934 season aboard the *Queen of Southend* and *Essex Queen* from the West Street Railway Pier. Gravesend has four passenger piers. The West Street Pier was originally linked to the old Gravesend West railway station that was closed due to the Beeching cuts. It was a calling point for famous pleasure steamers such as the *Royal Daffodil* and *Royal Sovereign*. *Waverley* also used it as a Thames base for a short time during the 1990s.

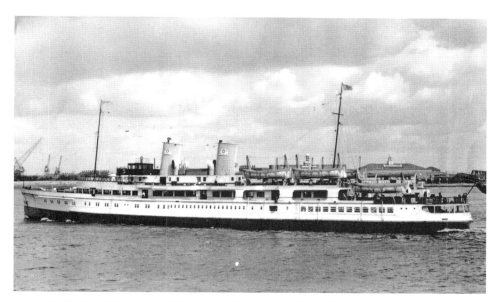

Royal Daffodil off Gravesend West Pier. Mr Loft was the well-known Gravesend agent for many years with premises close to the Town Pier as well as in New Road. *Royal Daffodil* was the first of the three large GSNC motor ships to be scrapped. Her departure from the London River was filmed and she arrived at the Ghent scrapyard on 1 February 1967.

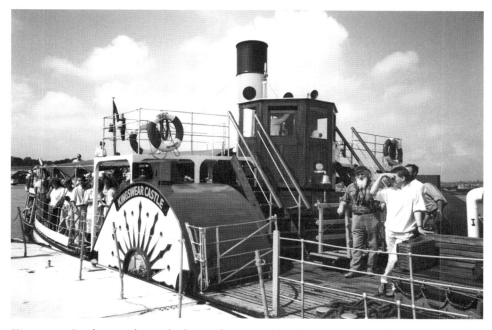

Kingswear Castle seen alongside the newly restored Sun Pier pontoon at Chatham in August 1987. This steamer could carry up to 235 passengers and operated primarily on the River Medway. She offered short cruises between Chatham Historic Dockyard to Strood and Rochester between 1984 and 2012.

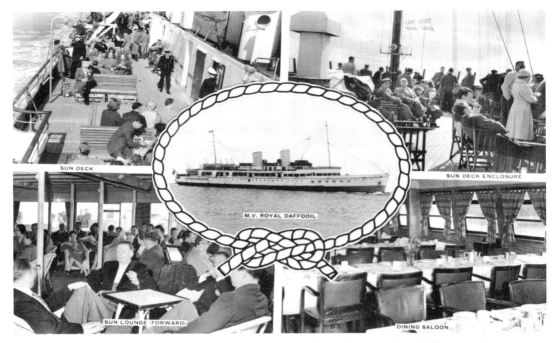

Views of the *Royal Daffodil*. This steamer was perhaps the most loved Thames pleasure steamer and could carry up to 2,073 passengers at a speed of 21 knots.

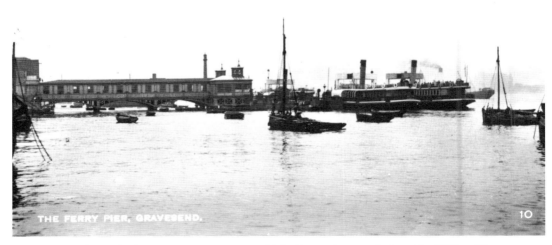

Ferries alongside the Town Pier at Gravesend. The Town Pier was designed by William Tierney Clark and as built by William Wood and opened on 29 July 1834. It cost £8,700 to build and was built on the site of the Town Quay that was recorded in the Domesday Book.

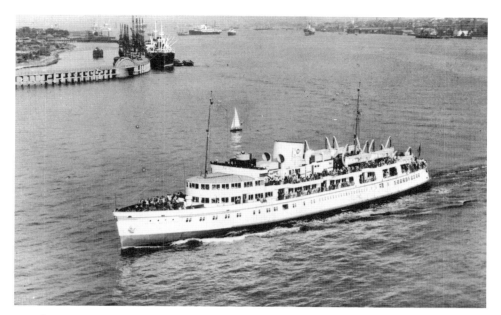

Royal Sovereign passing Gravesend during the mid-1950s. Rosherville Gardens once stood on the right of this picture. It became one of the most famed pleasure gardens on the Thames and had its own pier. Its position can still be identified by a decorative feature on the river wall.

The Royal Terrace Pier at Gravesend found its fame as the River Thames embarkation and departure point for royalty to London. One of the most notable events in its history was when Princess Alexandra of Denmark arrived at it to marry HRH The Prince of Wales. They later became Edward VII and Queen Alexandra. The Town Pier pontoon now stands in front of the gardens in this view.

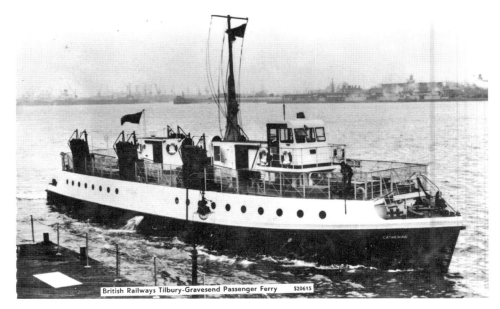

British Railways Tilbury-Gravesend Passenger Ferry S20615

The Gravesend to Tilbury ferry *Catherine* entered service on the Thames in 1961 along with her sisters *Edith* and *Rose*. These popular and well-designed ferries ran pleasure cruises to Tower Pier and Greenwich at weekends as well as occasionally on weekdays during the 1960s. *Catherine* was laid up in 1981 and was later sold for further use on the River Tyne.

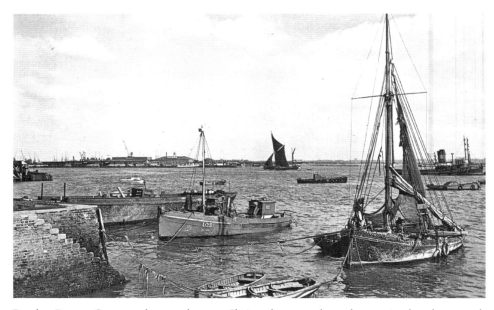

Bawley Bay at Gravesend around 1955. Shrimp boats such as the one in the photograph traditionally sailed from this bay to catch shrimps for the famous 'shrimp teas' that were sold in the nearby public houses of West Street. The Town Pier pontoon that was built in 2012 for *Waverley* and *Balmoral* is now positioned to the left of the image.

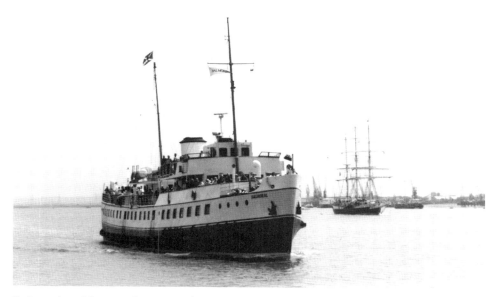

Balmoral cruising on the River Thames at Gravesend around 2005. Gravesend has four passenger piers. The West Street ferry pier was used for the Gravesend to Tilbury passenger ferry from the 1960s onwards. *Balmoral* has also used the pier on rare occasions. The nearby Town Pier at Gravesend is one of the most historic in Kent. It's the oldest cast iron pier in the world. When it was built it caused riots as watermen lost their livelihoods to row passengers ashore. The new pier allowed passengers to land at all states of the tide and had an open deck that allowed passengers to promenade on it.

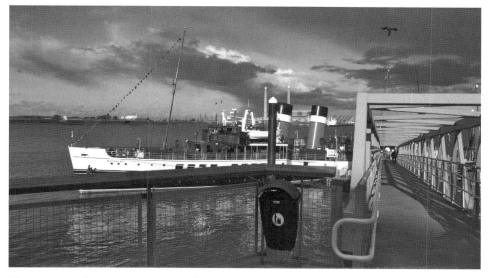

The 45-metre-long gangway onto the new pontoon at Gravesend Town Pier was erected in March 2012 after being assembled at Northfleet. The state of the art pontoon cost over £2.1 million to construct and the *Balmoral* and *Waverley* were two of the first pleasure steamers to use it.

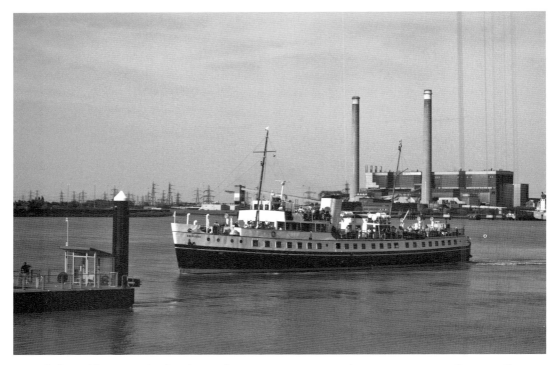

Balmoral becomes the first large pleasure steamer to use the new pontoon at Gravesend's Town Pier on 5 July 2012.

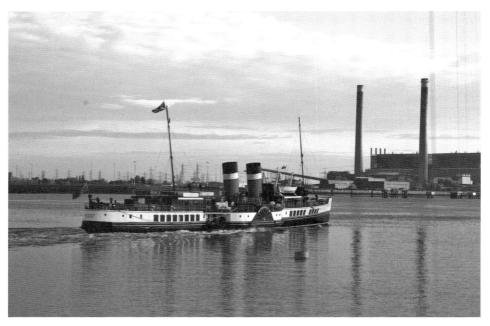

Waverley departing for the Firth of Clyde from the River Thames at Gravesend at the end of the 2012 season.

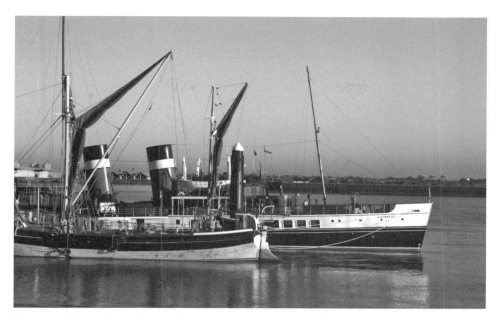

Gravesend Town Pier welcomed over 3,250,000 passengers between 1835 and 1842. By the late 1840s with the coming of the railways to North Kent and Tilbury, the emphasis changed as steamer services to and from London declined. Passengers then used the Town Pier for its ferry services to and from Tilbury to link up with the railways.

Chatham was hugely important to paddle steamers. Over the years it has been the home for the Medway fleet. Many of the steamers were berthed at Chatham during the winter. In more recent years it has welcomed the preserved steamers *Waverley* and *Balmoral* and was also the home for *Kingswear Castle* for over four decades.

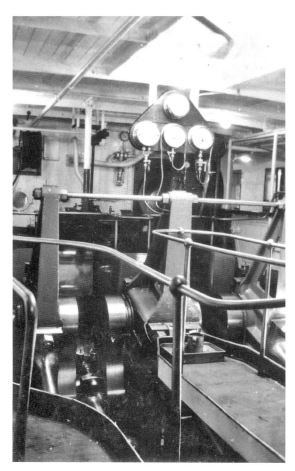

The engine room of the *Medway Queen* in 1963. She had a service speed of 15 knots and was 180 feet in length. Her engine was built by Ailsa of Troon and was coal-fired when built. This was later converted to oil in 1938. She had a regular cruising speed of 13 knots but could attain 15 knots if required.

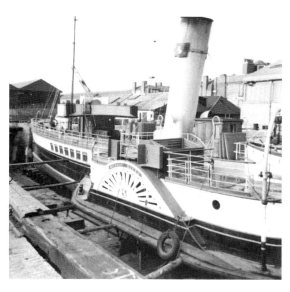

Medway Queen in the East India Dock during the couple of years after her withdrawal in 1963. Preservationists did a great deal to promote her heroism and uniqueness. In the years that followed she experienced a lot of uncertainty but has ultimately survived.

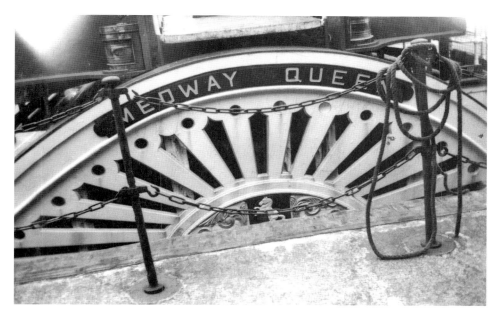

The paddle box of the *Medway Queen*. *Medway Queen* initially plied on the Strood to Southend service. She was launched on Wednesday 23 April 1924.

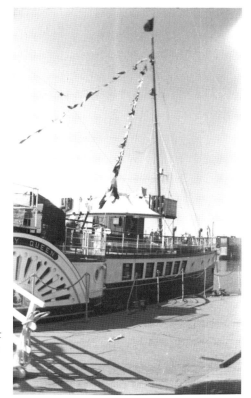

Medway Queen alongside Strood Pier in 1963 with flags flying to mark the end of her operational career. This pier took a great deal of trade from Chatham Sun Pier during the late 1950s. It was later used by the *Balmoral* and *Kingswear Castle* during the 1980s and 1990s.

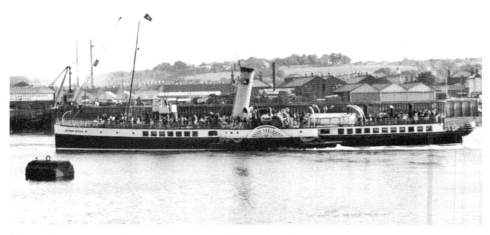

The *Medway Queen* departing on a cruise from Strood on 31 August 1963. *Medway Queen* was withdrawn from service a week later. Those final few weeks saw the steamer get massive publicity and thousands of photographs were taken. A massive campaign was launched by the Paddle Steamer Preservation Society to save and preserve the *Medway Queen* at the time.

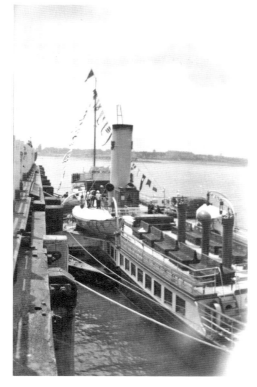

Medway Queen at Herne Bay during her last days in service. Her appearance had changed little since entering service in 1924. She also retained her open bridge until the end. She is now the last survivor of the famous Thames fleet.

The bow of the *Medway Queen* in 1962. *Medway Queen* was very much a Kent steamer and was synonymous with Chatham, the River Medway and the Kent resort of Herne Bay.

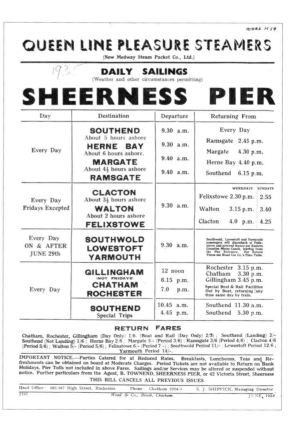

Sheerness Pier disappeared during the 1950s but in earlier years it was an important pier for pleasure steamers. This handbill from June 1935 lists the wide variety of cruises by the Queen Line at the height of Captain Shippick's reign with the NMSPC. Margate, Herne Bay and Ramsgate were well served for trippers. It was also popular for offering less exciting trips to the Medway towns.

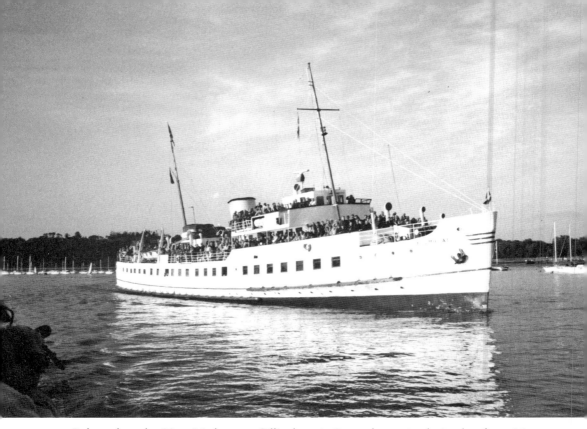

Balmoral on the River Medway at Gillingham in September 1987 during her first visit to Kent and the River Thames. *Balmoral*'s colour scheme at the time was similar to that of the three famous post-war motor ships. The late 1970s and early 1980s witnessed a flurry of exciting developments in Kent for large pleasure steamers. Despite the large steamers being withdrawn some twenty years earlier, it was the paddle steamer *Waverley* that showed a new way forward when she first visited the Thames in the late 1970s. She had spent her life on the Firth of Clyde and after being saved for preservation it became apparent that the Clyde wouldn't sustain her long-term preservation. After an initial trip to Llandudno and the Mersey in 1977, an ambitious timetable was drawn up to take her to places such as the Thames and South Coast. The success of this venture gave a boost to the restoration of the *Kingswear Castle* on the River Medway and she was steamed for the first time in 1983. She was perfectly suited to the River Medway and provided a superb addition to the growing heritage attraction of Chatham Historic Dockyard, where she operated a full annual programme of cruises from 1985 onwards.

During the early to mid-1980s it became apparent that *Waverley* would need a consort to deputise in case of mechanical failure as well as giving a need for piers and other facilities to exist. *Balmoral* entered service in 1986 to perform this important role. All three steamers operated a regular pattern of cruises in Kent after this point. A regular highlight of each season was the 'Parade of Steam' on the River Medway in Kent. This ended when *Kingswear Castle* was relocated to the River Dart at the end of the 2012 season. She departed from her Chatham base at the Historic Dockyard under the tow of the tug *Christine* early on the morning of 11 December 2012.

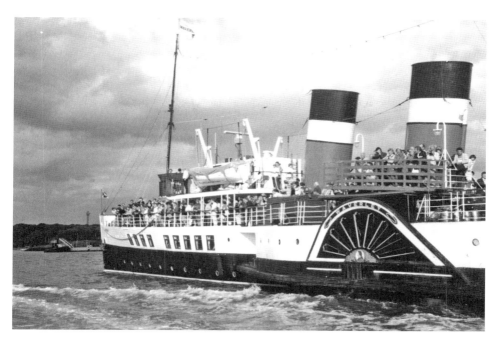

The famous *Waverley* during the 'Parade of Steam' on the River Medway around 1986. The parades became immensely popular during the late 1980s until 2012 when *Kingswear Castle* was moved to the River Dart. The two paddle steamers paraded together and provided an excellent finale to each season. *Waverley*'s decks were always fully packed with passengers!

Handbill advertising cruises from Herne Bay Pier to France in 1938. Herne Bay never gained the reputation for continental trips that its Thanet neighbours did. However, during the inter-war years it did offer an excellent range of 'no passport' cruises. Coach tours to the British military cemeteries were popular so that families could visit the graves of relatives lost during the First World War.

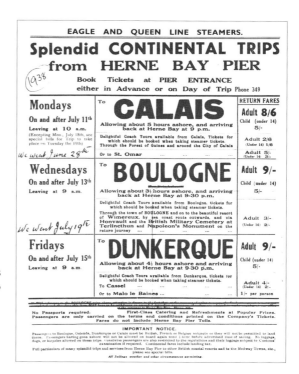

NEW BELLE STEAMERS
ANNOUNCE A SERIES OF SPECIAL SEPTEMBER
Sea Cruises from Southend
BY THE FAMOUS PADDLE STEAMER 'CONSUL'
Meals & Refreshments served in comfortable saloons at very reasonable prices. Music on Board

FULLY LICENCED BAR OPEN ALL DAY

Tuesday **17th** September	AT **12.15pm.** Arr.Back App. 6.30 pm	**Day return to HERNE BAY** Allowing over 2 hours ashore. Passengers may also remain on board for special cruise from Herne Bay.	Day Return ONLY **9/6** Inc: Sea Cruise **14/-**
	AT **6.30 pm.**	**Single trip to GRAVESEND** Ample time to return by train & ferry to Southend.	Single Fare **4/6**
Wednesday **18th** September	**3.45pm.** Returning At App: 5.10pm.	**Delightful Afternoon Sea Cruise** To view the River Medway, Kentish Coast, Isles of Grain & Sheppey.	REDUCED Return Fare **4/-**
	AT **5.15pm.** Arriving Back About 9.00pm	**Musical SHOWBOAT Cruise** Special Evening Up River to **Gravesend and Tilbury** A wonderful opportunity to view the Illuminations. BAND ON BOARD NON LANDING	Return Fare **8/6**
Thursday **19th** September	AT **2.35pm** Returning 4.15pm.	**Afternoon Sea Cruise** To view the Essex Coast, passing Shoeberryness Foulness & the Maplin Sands.	MIDWEEK Return Fare **4/-**
	AT **4.15pm**	Single trip to **Greenwich & London** Ample time to return by train to Southend.	Single Fare **6/-**
Friday **20th** September	AT **12.15pm** Returning App: 6.30pm	**Day return to HERNE BAY** Allowing over 2 hours ashore. Passengers may also remain on board for special cruise from Herne Bay.	Day Return ONLY **9/6** Inc: Sea Cruise **14/-**
	AT **6.30pm**	**Single trip to GRAVESEND** Ample time to return by train & ferry to Southend.	Single Fare **4/6**
Saturday **21st** September	**2.35pm** Returning App: 3.40pm	**Afternoon Sea Cruise** Around the Estuaries of the Thames & Medway	Return Fare **4/-**
	AT **3.45pm**	Single Trip to **Greenwich & London** Ample time to return by train to Southend.	Single Fare **6/-**
Final Sailings Sunday **22nd** September	**2.35pm** Returning App: 4.15pm	**Afternoon Sea Cruise** Up the Thames & over to the Medway to view Allhallows Canvey Island Shellhaven etc.	SPECIAL Return Fare **5/-**
	AT **4.15pm**	Single trip to **Greenwich & London** Ample time to return by train to Southend.	Single Fare **6/-**

All sailings subject to weather & circumstances permitting. Passengers are only carried on the terms & conditions printed on the back of the ticket. Tickets available on the Steamer and in advance from:- 144 Sumner Rd. S.E.I5 BER 3480 **REDUCED FARE CHILDREN UNDER 14.**

Herne Bay received a bit of a revival during the 1960s, when it welcomed the paddle steamers *Queen of the South* and the *Consul*. Both ventures were failures and Herne Bay never welcomed a large paddle steamer at its pier again.

THE PIER, HERNE BAY. K. 5668

Herne Bay Pier became council-owned in 1909 and in the following year an impressive new pavilion was constructed at the shore end. The pier suffered damage during the 1920s and was breached during the Second World War to stop it being used by the enemy. It was later repaired but gradually fell into disrepair. By 1968, the pier was closed.

Like Deal, Herne Bay has had three piers. The first was opened in 1832 and was one of the earliest seaside piers. Its length and facilities were quite unique at the time. It was constructed of wood and was a very impressive 3,613 feet long and cost over £50,000 to build. After damage, the pier had its piles changed to iron ones. At such a length, it was necessary to have transport for luggage and goods to the pier head. This was done by a sail-propelled wagon named 'Old Neptunes Car'.

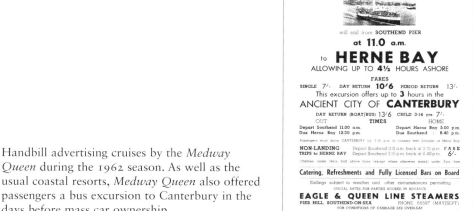

Handbill advertising cruises by the *Medway Queen* during the 1962 season. As well as the usual coastal resorts, *Medway Queen* also offered passengers a bus excursion to Canterbury in the days before mass car ownership.

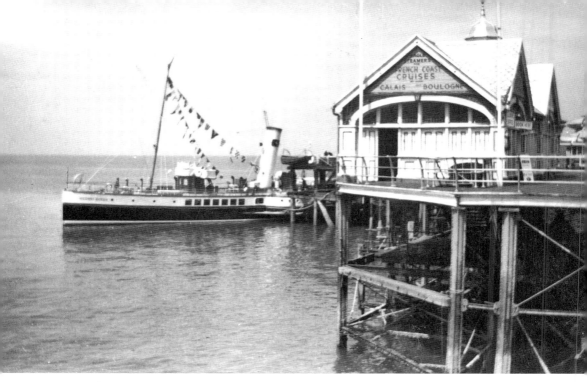

Medway Queen arriving at a Kent pier. At Thanet resorts, the marketing of cruises to France was heavily promoted due to their proximity to the French coast. *Medway Queen* never undertook such cruises but her bigger sisters of the Eagle & Queen Line did. Kent was lucky to have several famous piers. Like Deal, Herne Bay has had three piers. The first was opened in 1832 and was one of the earliest seaside piers.

The first iron pier at Herne Bay was demolished around 1870–1. It was replaced by a more modest structure some 415 feet long and was opened by the Lord Mayor of London in 1873. Despite having a grand pavilion, theatre and other attractions, it became apparent that a far longer pier was needed for the pleasure steamers and it was duly extended to 3,787 feet. The pier re-opened on 14 September 1899. 1978 saw the pier severely damaged by heavy storms and the pier head became detached. 1978 also marked a new era in the pier's history when the new and modern bowling alley and leisure complex was constructed on the site of the old pavilion. This bowling alley was demolished in 2012, leaving the shore end of the pier as a flat expanse of decking. Plans are, though, afoot to rebuild the pier. This would cost in the region of £12 million.

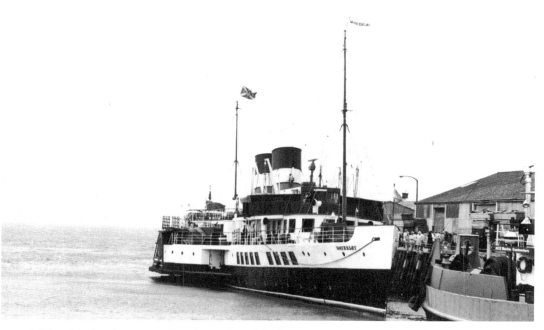

Whitstable has become a firm favourite with pleasure steamer passengers from the 1980s onwards. The quaint harbour with its fishing and tourist activities provides a perfect destination for passengers from London, Kent and Essex, as seen in this photograph from 1985.

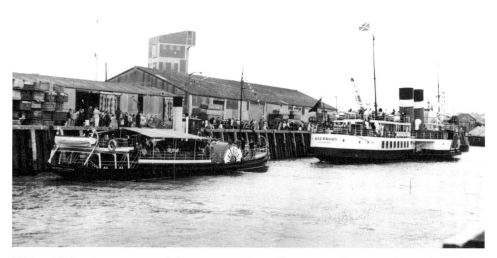

Whitstable has become one of the most popular calling points for *Waverley*, *Balmoral* and *Kingswear Castle* since the 1970s. Its traditional fishing boats, quaint shops and cafés have made it an ideal calling point for steamers from London, Gravesend and Southend.

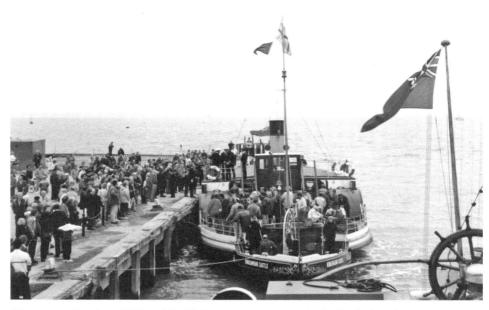

Kingswear Castle at Whitstable. This steamer was originally built for the River Dart in Devon in 1924. After paddle steamer services ceased on the Dart in 1965, she was towed to the Medway for restoration. Her subsequent restoration and successful operation on the Thames and Medway gave the steamer a strong Medway link.

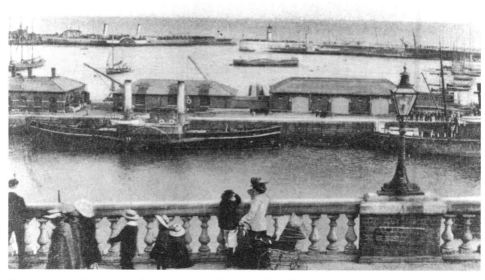

Ramsgate harbour dates from 1795 and the two breakwaters enclose an area of 42 acres. The construction of Ramsgate harbour cost around £1,500,000. The east pier was enlarged in 1894 to accommodate the large paddle steamers that called at the resort. The paddle tug *Aid* can be seen in this view.

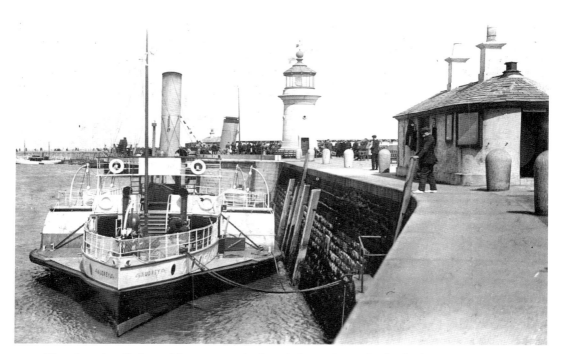

The charming little paddle steamer *Audrey* tied up alongside the harbour at Ramsgate around the late 1920s. *Audrey* was one of the steamers acquired by the ambitious Captain Shippick for the New Medway Steam Packet Company.

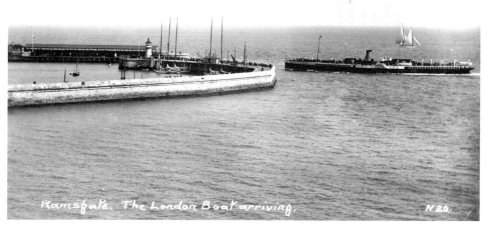

Crested Eagle arriving at Ramsgate. *Crested Eagle* was perhaps the most distinctive of all Thames paddle steamers. She had a lack of prominent deckhouses and a squat telescopic funnel that enabled her to pass under London Bridge. She had a particularly attractive first-class dining saloon, with large panoramic windows, situated on the main deck. She also had the distinction of being the first oil-burning paddle steamer in Europe.

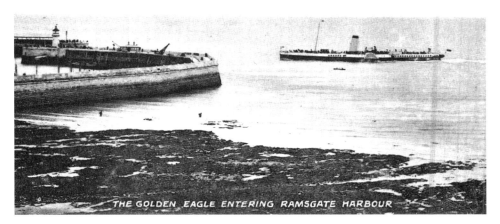

Golden Eagle arriving at Ramsgate. In 1915, the *Golden Eagle* carried 119 officers and men and six aircraft of the newly formed Royal Naval Air Service from Dover to Dunkirk. One of these, flown by Lieutenant Warneford, brought down the first Zeppelin to be destroyed by a British plane.

Ramsgate gained its popularity due to the summer patronage of royalty such as George IV. In recognition of the hospitality that he received, he gave it the prefix 'Royal', making it unique in the UK. The town really developed during the Victorian period after further patronage from the young Princess Victoria.

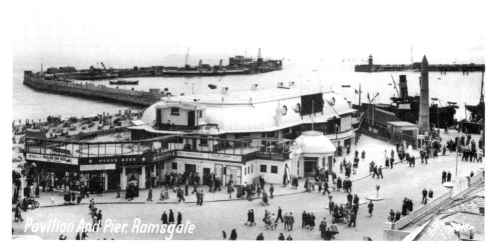

Pavilion And Pier, Ramsgate

A view of Ramsgate harbour during the mid-1930s. One of the two converted ex-minesweepers is alongside the harbour wall. The scene has changed very little since the time of the photograph, although Ramsgate's popularity has dwindled and the harbour is less crowded with tourists these days.

Handbill advertising cruises by the *Queen of Thanet* from Margate and Ramsgate. Both of these resorts were ideally placed to offer quick crossings to France, taking around two hours in each direction. This allowed around four hours ashore. Coach tours were popular for those landing in France. Tours of battlefields were particularly popular during the inter-war years.

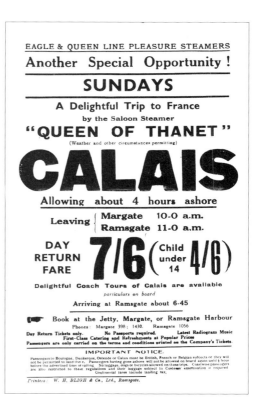

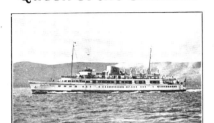

Queen of the Channel was a well-known fixture on the East Kent coast and in particular at Ramsgate. *Queen of the Channel* as a great favourite among the post-war clientèle of the Eagle Steamers. She bore a great likeness to the *Royal Sovereign* that had been built at the same Denny of Dumbarton yard just a few months previously. Her pre-war namesake was more like the *Royal Daffodil*, as it had two funnels.

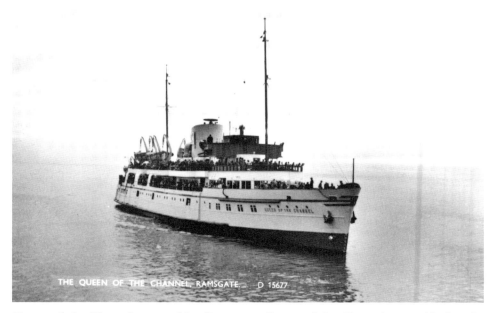

THE QUEEN OF THE CHANNEL, RAMSGATE. D 15677

Queen of the Channel approaching Ramsgate. *Queen of the Channel* was sold after the cessation of Thames services by the GSNC in the mid-1960s. She initially became *Oia* for service in Greece before later being renamed *Leto*. She was finally broken up in March 1984 at Eleusis.

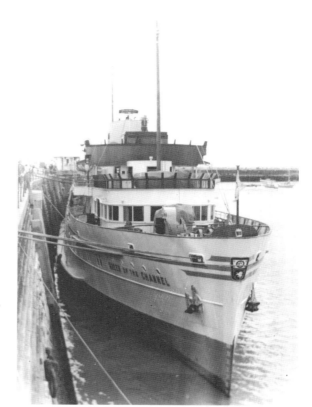

Queen of the Channel at Ramsgate during the early 1960s. *Queen of the Channel* was very popular at Ramsgate and had operated from the resort during her first season of service. She undertook French coastal tours as well as cruising to Dover and onwards towards Dungeness.

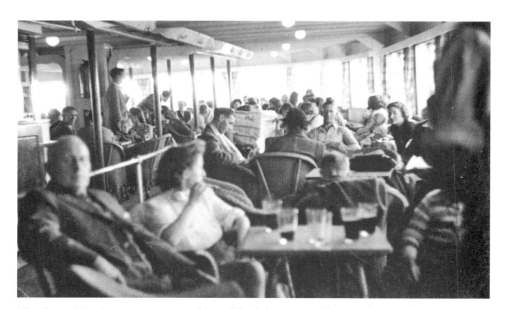

The three GSNC post-war motor ships all had distinctive 'blisters' that ran for around 150 feet along each side of the hull. This view of one of the large lounges shows the great width of the steamer. Open decks surrounded this lounge.

Ramsgate offered many attractions for passengers disembarking at the resort. One of the most popular of these was the Model Village on the West Cliff. Ramsgate was one of the most popular seaside resorts of the nineteenth century. Its impressive harbour has always been its best feature. It played a major part in the Dunkirk evacuation of 1940 as it became the main assembly point for the build-up of pleasure steamers and small boats used in the evacuation.

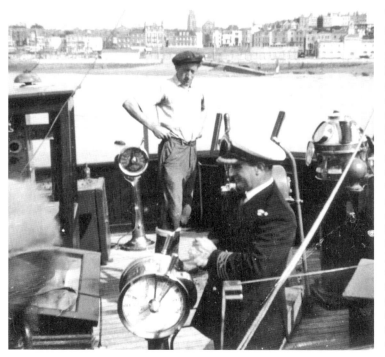

The open bridge of the motor vessel *Crested Eagle* at Ramsgate in 1953. Her Ramsgate cruises were local ones and she operated here from 1952 for a while. She had a modest operating speed of 14 knots, which made her an excellent member of the GSNC fleet. She was sold for further service at Malta in 1958 and continued working there until being sold and sunk as an underwater attraction for divers in 1995.

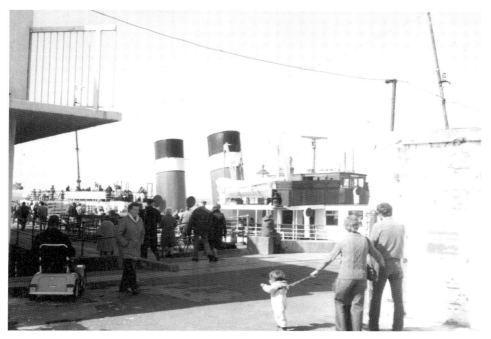

Waverley tied up alongside the harbour wall at Ramsgate in 1983. This was the spot that was formerly used by the Eagle Steamers.

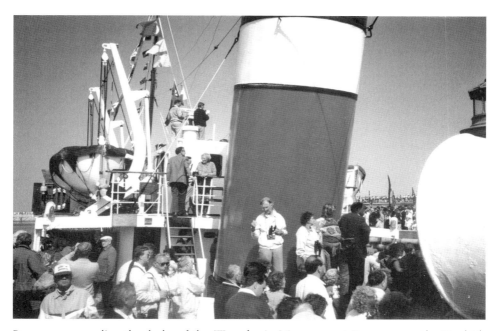

Passengers crowding the decks of the *Waverley* in May 1990 at Ramsgate as the Dunkirk little ships arrive back after their peacetime commemorative to France. The Royal British Legion can be seen on the harbour wall providing a guard of honour.

Waverley alongside the harbour at Ramsgate during the fiftieth anniversary commemorations of the Dunkirk evacuation. After she had arrived back at Ramsgate, the little ships were welcomed back by passengers as they passed her bow at the entrance to the harbour.

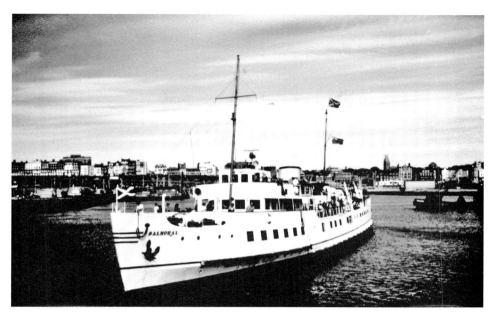

Balmoral at Ramsgate during her very first visit to the Thames in September 1987. *Balmoral* unexpectedly made this visit after *Waverley* had been withdrawn due to boiler problems and showed her ability to deputise for the paddler in times of trouble. *Balmoral* provided a wonderful sight at Ramsgate with her cream-and-pale-green livery that was reminiscent of the fondly loved Eagle Steamers.

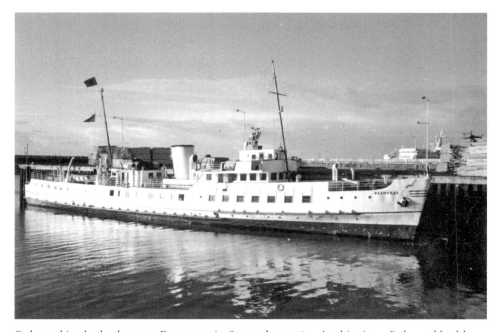

Balmoral in the harbour at Ramsgate in September 1987. At this time, *Balmoral* had been undertaking cruises in her preservation career for just over a year.

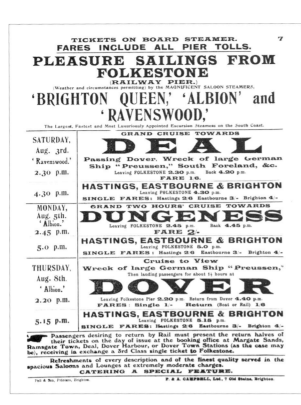

PLEASURE SAILINGS FROM FOLKESTONE

(RAILWAY PIER.)

(Weather and circumstances permitting) by the MAGNIFICENT SALOON STEAMERS,

'BRIGHTON QUEEN,' 'ALBION' and 'RAVENSWOOD,'

The Largest, Fastest and Most Luxuriously Appointed Excursion Steamers on the South Coast.

SATURDAY, Aug. 3rd. 'Ravenswood.' 2.30 p.m.	**GRAND CRUISE TOWARDS DEAL** Passing Dover. Wreck of large German Ship "Preussen," South Foreland, &c. Leaving FOLKESTONE 2.30 p.m. Back 4.20 p.m. FARE 1 6.
4.30 p.m.	**HASTINGS, EASTBOURNE & BRIGHTON** Leaving FOLKESTONE 4.30 p.m. SINGLE FARES: Hastings 2 6 Eastbourne 3 - Brighton 4/-
MONDAY, Aug. 5th. 'Albion.' 2.45 p.m.	**GRAND TWO HOURS' CRUISE TOWARDS DUNGENESS** Leaving FOLKESTONE 2.45 p.m. Back 4.45 p.m. FARE 2/-
5.0 p.m.	**HASTINGS, EASTBOURNE & BRIGHTON** Leaving FOLKESTONE 5.0 p.m. SINGLE FARES : Hastings 2 6 Eastbourne 3 - Brighton 4/-
THURSDAY, Aug. 8th. 'Albion.' 2.20 p.m.	**Cruise to View** Wreck of large German Ship "Preussen," Then landing passengers for about 1½ hours at **DOVER** Leaving Folkestone Pier 2.20 p.m. Return from Dover 4.40 p.m. FARES : Single 1/- Return (Boat or Rail) 1/6
5.15 p.m.	**HASTINGS, EASTBOURNE & BRIGHTON** Leaving FOLKESTONE 5.15 p.m. SINGLE FARES: Hastings 2 6 Eastbourne 3 - Brighton 4/-

Passengers desiring to return by Rail must present the return halves of their tickets on the day of issue at the booking office at Margate Sands, Ramsgate Town, Deal, Dover Harbour, or Dover Town Stations (as the case may be), receiving in exchange a 3rd Class single ticket to Folkestone.

Refreshments of every description and of the finest quality served in the spacious Saloons and Lounges at extremely moderate charges.
CATERING A SPECIAL FEATURE.

Pell & Son, Printers, Brighton. P. & A. CAMPBELL, Ltd., 7 Old Steine, Brighton.

Folkestone once operated a large number of cruises from the pier. This handbill from 1914 lists some of these. Folkestone was placed in the centre of several large resorts in Kent and Sussex and passengers were able to see a great amount of shipping as well as wrecks. Return journeys were often made by train, thereby allowing P & A Campbell to operate a busy and lucrative timetable.

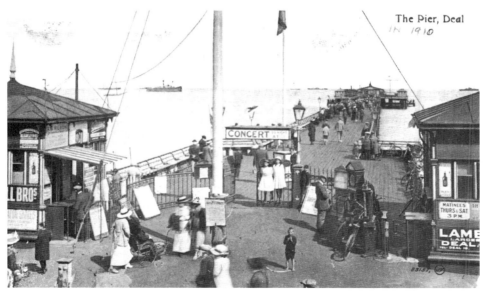

The Pier, Deal in 1910

Deal Pier in its Edwardian heyday. The pier was always a somewhat basic structure, without the developed pleasure structures that covered others. It was a pier mainly for promenading and for steamers. Concerts and cafés were the only attraction. The pier, although rebuilt, has remained similar to this day and has the same visual appearance even down to the shore-end kiosks.

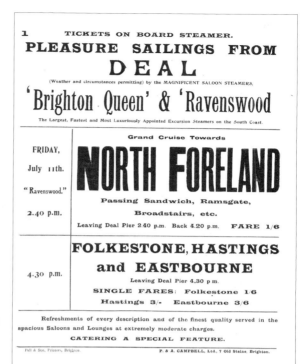

Deal Pier was once a busy calling point for paddle steamers. This handbill from 1913 lists some of the cruises by the famous paddle steamers *Brighton Queen* and *Ravenswood* to the Sussex resorts of Eastbourne and Hastings as well as northwards to the North Foreland.

Deal from Pier

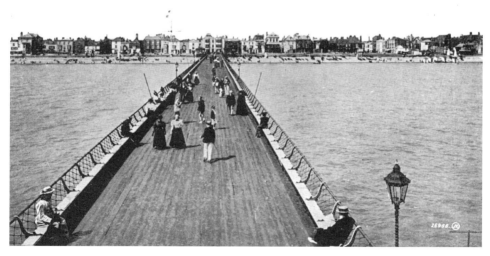

The view from the pier head at Deal is a splendid one. The many ancient houses and pubs were once the homes of smugglers and Deal can claim to have had a colourful past. The seafront has remained virtually unchanged, and luckily the pier has always survived. It gives the very best view of the historic buildings that face the sea.

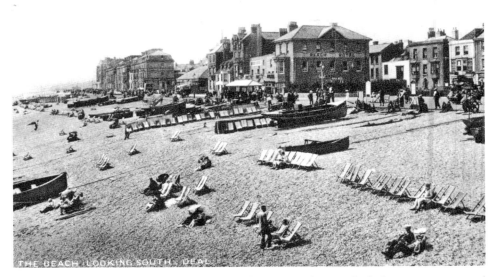

The beach to the south of Deal Pier around 1930. Deal never had the amusements and pleasure palaces of its neighbours at Margate and Ramsgate. Instead, it gave passengers from the pleasure steamers more simple facilities such as sunbathing on the beach.

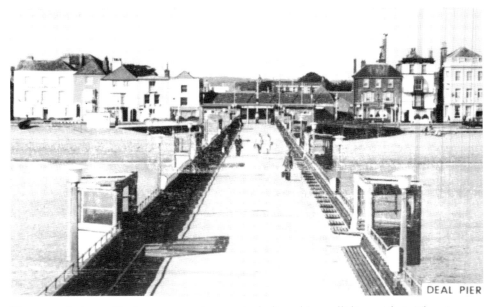

DEAL PIER

The second pier at Deal saw many dramas, including ships colliding with it. The pier was later bought by Deal Borough Council in 1920 for the sum of £10,000. During the early part of the Second World War, Deal Pier was badly damaged after a steamer collided with it. It was subsequently demolished after orders from Sir Winston Churchill to enable coastal artillery clear views of the enemy in the English Channel. This image shows the present pier, which was the replacement for it.

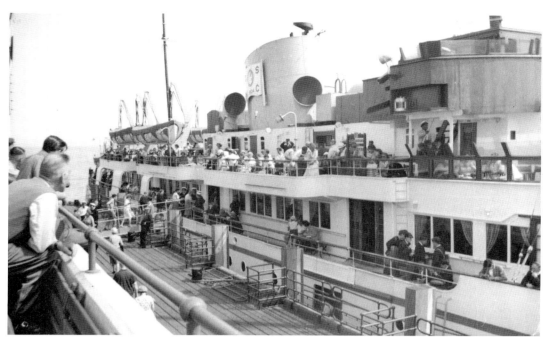

Queen of the Channel at Deal Pier in 1964. Popular cruises to France for time ashore at Boulogne and Calais commenced again after the 1955 season. These had been stopped due to the war and clearing war debris in the decade after the end of hostilities.

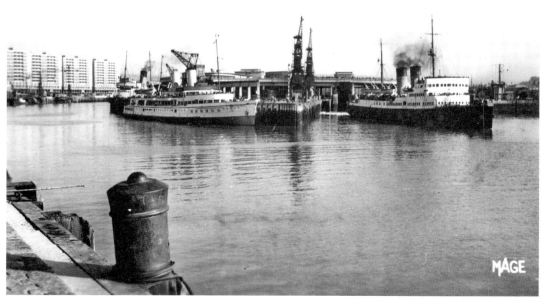

Royal Daffodil at Boulogne. The three post-war Eagle Steamer motor ships were familiar visitors to Boulogne and Calais.

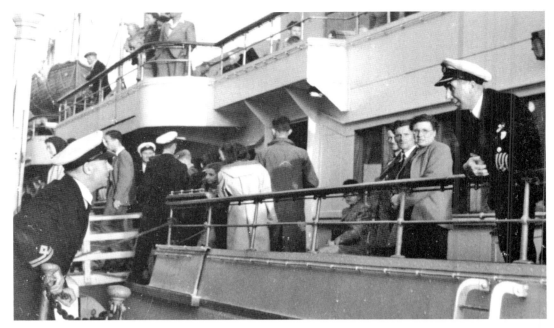

The three Eagle Steamer motor ships were perhaps some of the greatest steamers ever made by Denny. This photograph shows the pleasant, wide decks that circled even more pleasant covered passenger accommodation. They also possessed multiple embarkation points that could fill or empty a steamer in minutes.

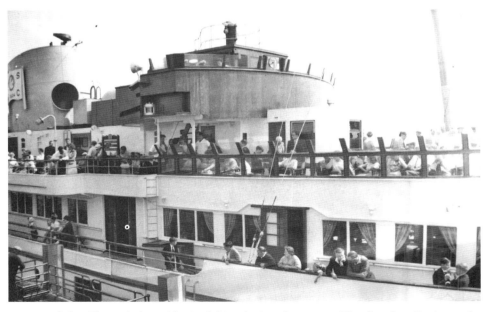

Queen of the Channel alongside Deal Pier during the 1960s. The fine Sun Deck can be appreciated in this view with its protective glass panels. The pier head landing facilities still exist, although the timber piles were sawn off during the 1980s.

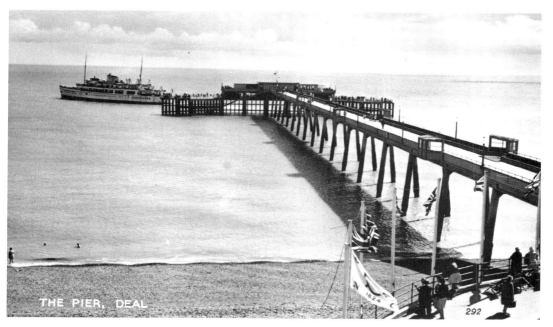

THE PIER, DEAL 292

Queen of the Channel departing from Deal in the early 1960s. The length of the pier is
1,026 feet. The pier had a small kiosk positioned either side of the promenade entrance as
well as a comfortable café with extensive panoramic views at the seawards end of the pier.
The GSNC house flag can be seen flying at the entrance.

293

PIER APPROACH, DEAL. (LOOKING SOUTH)

The new Deal Pier was opened by HRH The Duke of Edinburgh on 19 November 1957. In
2008, the old café and toilets were demolished to make way for new facilities.

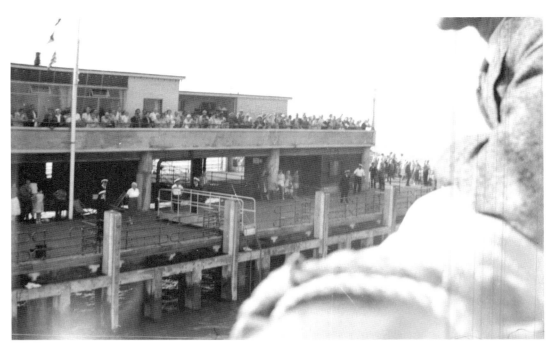

Queen of the Isles arriving at Deal Pier in 1968. Various attempts were made to operate pleasure steamers to places such as Deal during the late 1960s and 1970s but they were never a success.

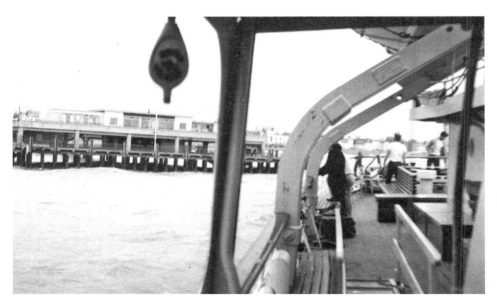

Queen of the Isles off Deal Pier on Tuesday 7 September 1968. This rare photograph shows the fine facilities available to steamers at the East Kent pier. Sadly, the landing stage never saw significant use as the Eagle Steamers had gone less than ten years after the pier was opened.

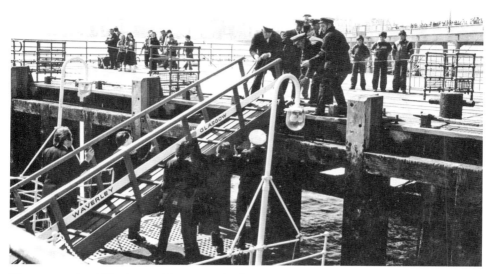

The present Deal Pier is notable as it is the last completely new pier to be built in the UK since the Second World War. The pier head has a distinctive arrowhead design. The last pleasure steamer to call at it was the *Waverley* in the early 1980s.

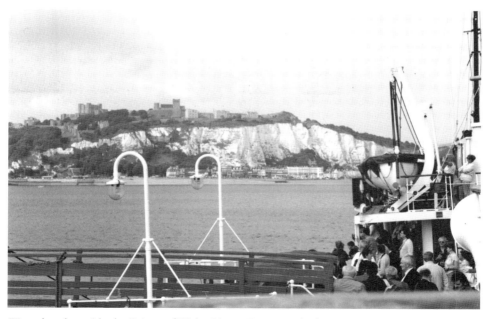

Waverley alongside the Prince of Wales Pier at Dover in the late 1980s. *Waverley* has been a frequent visitor to Dover during most of her Thames career. In early years she would offer a range of cruises including those to and from Ramsgate. In later years, cruises were offered to London.

SAILINGS FROM DOVER

By

Eagle and Queen Line Steamers

Cross Channel Luxury Liner T.S.M.V.

"Queen of the Channel"

From 4th JULY, 1950

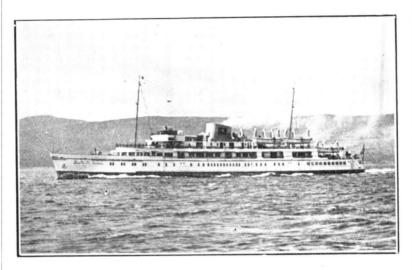

will leave PRINCE OF WALES PIER, DOVER
at 11.30 a.m.
Every TUESDAY, WEDNESDAY & THURSDAY

For a

Five Hour Channel Cruise
Off the French Coast

ADULTS 10/6 CHILDREN (3–14) 5/3

Including Admission to Pier

This Magnificent Ship, launched last year, has accommodation for about 1000 Passengers. — **Luncheons, Teas, Fully Licensed Bars available on board.**
Sailings subject to weather and other circumstances permitting. No Dogs carried on the Company's Steamers. Passengers are only carried on the terms and conditions printed on the Company's Tickets.

Booking at Company's Booking Office, Prince of Wales Pier Gate, from one hour before sailing, also at the Folkestone, Dover & Deal offices of the East Kent Road Car Company
Or from **GEORGE HAMMOND & Co.,** Shipping Agents,
3 STROND STREET, DOVER (Telephone Dover 1201)

Printers—W. H Bligh & Co., Ltd., Ramsgate Ref. Dover 50/1

Cruises by the new *Queen of the Channel* from the Prince of Wales Pier in 1950. Channel cruises were immensely popular despite the inability at that time to land in France as well as the likelihood of seasickness.